HOW TO PAINT
ABSTRACTS

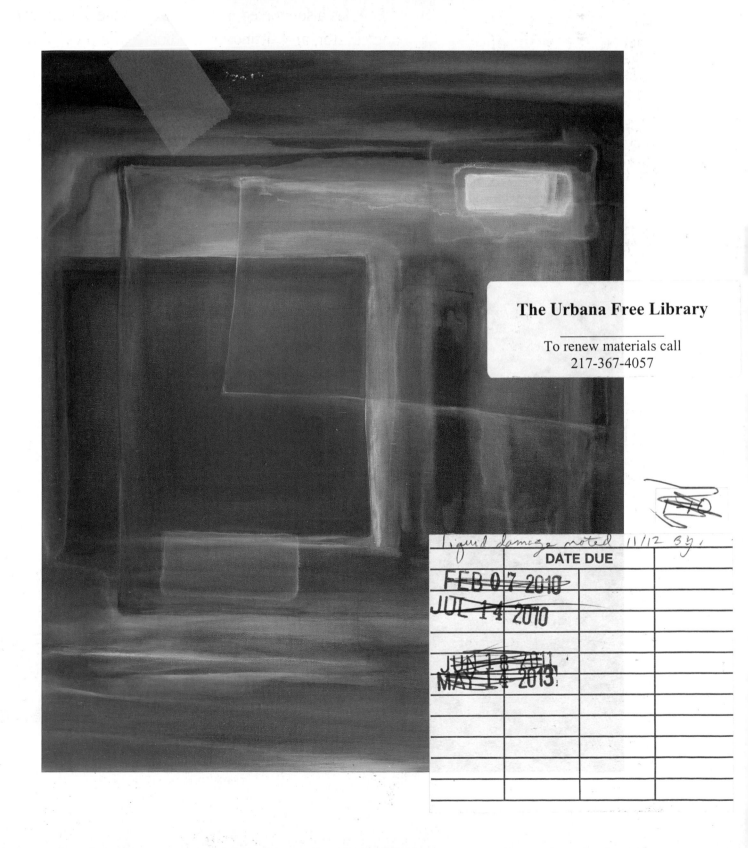

Dedication

*Dedicated with love to my
beloved Grandmother Jean, my
parents Jane & Jon, and also
to Carol, Elizabeth and Valerie
who support and inspire me.*

With love & thanks to Andrew.

HOW TO PAINT
ABSTRACTS

DANI HUMBERSTONE

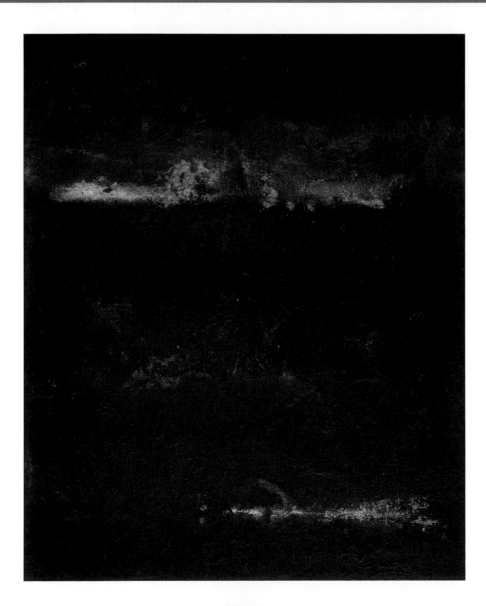

SEARCH PRESS

First published in Great Britain 2009

Search Press Limited
Wellwood, North Farm Road,
Tunbridge Wells, Kent TN2 3DR

Text copyright © Dani Humberstone 2009

Photographs by Roddy Paine Photographic Studios

Photographs and design copyright © Search Press Ltd. 2009

ISBN: 978-1-84448-290-0

The Publishers and author can accept no responsibility for any consequences arising from the information, advice or instructions given in this publication.

Suppliers
If you have difficulty in obtaining any of the materials and equipment mentioned in the book, please visit www.winsornewton.com for details of your nearest Premier Art Centre.

Alternatively, please phone Winsor & Newton Customer Service on 020 8424 3253.

Publishers' note

All the step-by-step photographs in this book feature the author, Dani Humberstone, demonstrating abstract painting. No models have been used.

You are invited to visit the author's website at:
www.danihumberstone.com

You can visit Dani's studio and shop at:
The Art Shop,
High Street,
Wadhurst,
East Sussex
TN5 6AJ

Printed in Malaysia

Acknowledgements

Thanks go to Jenny Reeves and Carol Geer for their kind permission in returning my paintings Spiritus Aquarius (see page 7), Light Fantastic (see page 21), Apple Aurora (see page 23) and Venice (see page 27) to be photographed for this book.

Thanks also to 'Altered Images' (Framers) with grateful thanks for their support, patience and chocolate, and to Alison Trask for looking after my shop, which allowed me to write this book!

To Sophie, who kindly found me geraniums in mid-winter, and to Edd who is fab.

Cover
Seeker
30 x 30cm (12 x 12in)
Using many of the elements found in the book, this piece is a good demonstration of light, tone and colour balance.

Page 1
Love Letter
61 x 91cm (24 x 36in)
Here is a love letter in pictorial form. Notice the darker element behind the others on the left, which represents hidden feelings.

Page 3
Homage to Mr. Rothko
61 x 91cm (24 x 36in)
In direct response to my having seen a Rothko exhibition, in this picture I have tried to capture similar luminosity to the originals.

Opposite
Orange Square
30 x 40cm (12 x 16in)
Using the complementary colours of blue and orange, note how the warm orange square advances from the cool blue and green background.

Contents

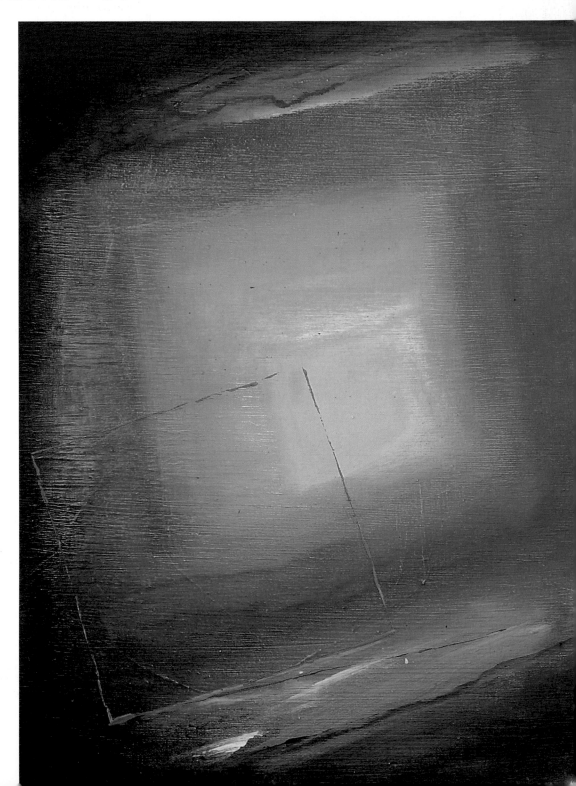

Introduction

To see a world in a grain of sand,
And a heaven in a wild flower,
Hold infinity in the palm of your hand,
And eternity in an hour.

FROM *AUGURIES OF INNOCENCE*, BY WILLIAM BLAKE

Until the mid-nineteenth century, an artist was the only means of recording a face, a building or a scene. Following the development of the camera, however, art began to go through considerable changes. Artists found themselves on the edge of something entirely new – a movement of experimentation and innovation that pushed through tradition and the received wisdom of the time. Artists began to make paintings that did more than represent life as it stood before them: famously shown by the Impressionist movement. This led on to abstract art in general.

Abstract art, in any and all its forms, is not about what we see and hear in front of us. A beautiful landscape can tell a story and a portrait can tell us much about the sitter and their part in history; but painting a representation of how we perceive our world – how we communicate, feel, hope and dream – is very different.

Abstract art is about us as individuals; about our understanding of the human condition – its strengths and frailties, beauty and horror. These compel us to look further than the here and now.

In abstract art, we use the languages of symbolism, the unconscious and instinct to show these hidden parts of life. This book will introduce you to making abstract art, guiding you through four projects to abstraction.

Confidence plays a large role in all art, and abstract art is no exception. By the time you have worked your way through to the end of this book, I hope you will have gained in confidence and inspiration by harnessing your potential – and that you will continue on your own journey as an abstract painter.

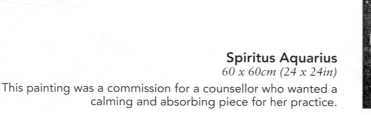

Spiritus Aquarius
60 x 60cm (24 x 24in)
This painting was a commission for a counsellor who wanted a calming and absorbing piece for her practice.

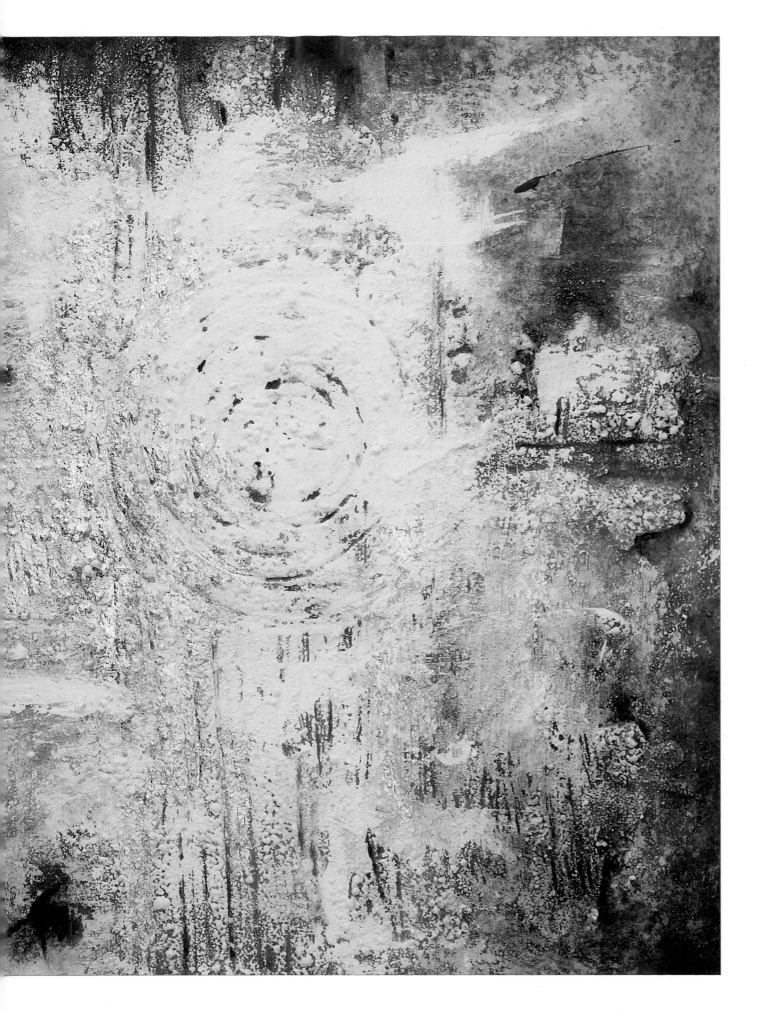

Materials

Media

In this book I use a number of different media, all available from your local art store. These are all water-soluble, meaning that you can use water as a thinner – and also to clean them up!

The media used in the book are a starting point: there are many more out there, such as oil paints, coloured pencils and charcoal. I would recommend that you experiment with as many different media as you choose, and feel free to use more than one in a picture. I often use two or three, as this gives depth to the final result.

Acrylic paints

Acrylic paints have been around since the mid 20th century, when pigment was combined with a polymer or plastic base, rather than the oil of oil paints and the water base of water colours. One of the first users of the new medium was one of my heroes, Mark Rothko, who was one of the greatest exponents of abstract expressionism.

Originally the colour range of acrylic paints were fairly restricted due to the polymer base rejecting some of the pigments used to make up colours. Nowadays, the ranges are as good as any other medium. My favourite is the artists' range from Winsor and Newton. Many of the colours in this range are 'mono-pigmented' which means that the principle colour in the tube has had no other colour or hue added to it. This results in incredible brilliance with no colour shift from wet to dry colour.

The Galeria range of acrylics, aimed at students, is also great for large area coverage and has an excellent colour range.

Water colour

Water colour has been with us for a couple of centuries and is probably still the most popular medium. The colours are made up from dyes, pigments and hues with the primary binder gum Arabic. Water colours are made from both organic and synthetic pigments and dyes, and can be transparent, semi transparent or opaque. The principle idea of water colour is the use of water, this brings out the beauty of the transparent colours.

Gouache

Gouache is basically an opaque water colour, which gives it a smooth bright opaque finish. You can use gouache on top of and alongside water colour for all sorts of exciting effects.

Pastels

Pastels are in some respects our most ancient painting medium, since prehistoric times we have been applying colour to walls using some sort of binder. However only since the 18th century have we been using pastels in a more recognisable way. Made almost entirely from pigments they are mixed and rolled with a vehicle (usually gum Arabic) then shaped and dried.

A very versatile medium, they are perfect for slipping into a bag or pocket for instant or outdoor sketching. Pastels can be used alongside water colour and gouache paints.

The pastels used in this book are chalk or soft pastels. Oil pastels are also available, but I felt that the blending quality and luminosity of chalk pastels lent them the edge for the projects in this book.

Tip

Some media work well over others – and some not so well! Try to avoid using oil paints over any of the water-soluble media. Similarly, pastels should be kept until last, as the other paints struggle to adhere to them, which spoils the effect.

Tip

Chalk pastels work well with water colour and gouache, but oil pastels work better with oil paints if you want to experiment.

Acrylic paints are available in tubes and pots, and are great for combining with other media. Some shop-bought auxiliaries that work well with acrylic paint are gloss, matt, and gel mediums; flow improvers and retarder; and carvable modelling paste. All of these give different effects.

You can also use some more familiar items, such as cat litter, sand, beads, kitchen roll, plaster of Paris and ash.

Water colours are available in pans or tubes; and you can augment them with various auxiliaries, such as aqua pasto, masking fluid, granulating medium, gum Arabic, ox gall and texture mediums.

Again, some household items such as sea salt can enhance them. Sprinkle this over wet paint: the salt absorbs some water where it falls and gives a starry mottled effect when the paint dries.

Gouache is available in tubes and jars, and it works well with the same auxiliaries as water colours.

While paper is the most common surface to use with pastels, you can use soft pastels on canvas too.

There are no auxiliaries as such for pastels, but I would recommend a fixative to ensure the pastel stays on the surface you have used.

Mark-making tools

There are many different ways to apply the various media to the surface. Here are just a few that I use.

Paintbrushes

Probably the most traditional way to apply paint to a surface, brushes can be made up of just about any kind of hair or bristle, either synthetic or natural. The most common natural hairs used are sable, hog hair, squirrel, goat and pony hair. Synthetic brushes are fantastic nowadays, I particularly like Winsor & Newton's Galeria and Eclipse series.

The metal shaft containing the end of the brush you don't see is called the ferrule, and in well-made brushes the hair or bristle should go all the way down to where it meets the wood of the handle.

Brushes can be used with any painting medium, including chalk pastels. Traditionally, sable has been used with water colour whilst hog hair/bristle leans towards oils and acrylics. However, this is not a rule by any means and it is definitely worth trying different brushes and mediums.

Tip

Brushes are like shoes; a well made pair will last a lifetime! It is a much better idea to buy yourself a couple of really good brushes rather than lots of cheaper ones.

Palette knives

Palette knives come in a variety of shapes and sizes from tiny trowels to long knives that look a little like a butter knife. Made from strong flexible stainless steel with wooden handles, they are a very exciting tool to use with both oils (inc oil pastels) and acrylic and can be used in a variety of ways. They are fantastic on large canvases or surfaces giving scope and freedom of movement.

Tip

Palette knives are great for mixing up colours, applying texture gels and scraping off unwanted or dried paint from your palette.

Pen and ink

There are many way of using ink. It is a lovely medium with which to draw, add detail or spatter. Winsor & Newton Drawing Inks are made from soluble dyes in shellac solution (made from shellac beetles).

In this book I have used black Indian drawing ink and a dip pen as I prefer this way of working, but a drawing pen with ink integral is a good alternative and less messy – great, unless you like mess!

Drawing inks are clean and vibrant and come in a huge variety of colours, so I definitely think that they are worth experimenting with.

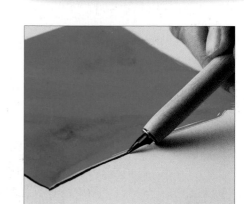

Tip

You can also use inks with a brush. Inks can be used alongside virtually any media, including water colour and gouache.

Rag

The humble rag is an essential part of an artists' toolkit (along with the omnipresent kitchen paper). They can be used for many effects and techniques, such as lifting out, spreading wet paint, blotting unwanted paint and of course cleaning up!

The best rags are lint-free but I have used many things. Old tee-shirts, sweatshirts and soft towels are especially good.

Tip

There are many household items you can use as painting tools, it is really just a case of having a go and not restricting yourself to more traditional way of applying paint. Here are a few suggestions:

Toothbrush – useful for flicking and spattering paint (see page 18)
Comb – Like the fork (below), this can be used to scrape patterns.
CD/DVD – Cut into pieces, these are useful to spread paint.
Cardboard/paper – Blot these on wet paint for a textured effect.
Newspaper – Stuck on for a collage base, this is cheap and useful.
Wire – Used for scraping details.
Plastic cups – These make fantastic circular marks in wet paint.
Paper plates – Like CDs, cut these into any shape to spread paint.

Fork

I find an ordinary stainless steel fork is ideal for *sgraffito* work, using the fork prongs down will give you a strong effect whilst using it on its side a single line. The harder you press, the more paint you will scrape off giving the effect of lightening the area you've worked on.

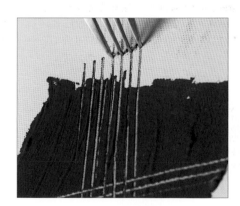

Tip

Apparently scientists have proven that a glass of wine (or two) can seriously help artists with their work as it frees inhibitions, so now there's a brilliant excuse...

Hands and fingers

These are far and away the best and most flexible tools you will ever have. Using your hands to apply when painting abstracts can give you a more direct response to your work with nothing getting in between you and the painting. At the same time, this approach gives you a real subtlety of touch when blending colour on the canvas or support.

It is important that you try to be as loose as possible as you work with this book, by sometimes using your hands as you paint, I hope you will find a more playful element to what you are doing.

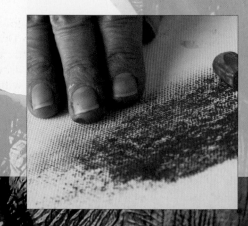

Surfaces

With your mark-making tools in hand, and your paint neatly (or perhaps not so neatly) laid out, you need something to apply it to. Almost anything will do as long as it has been primed. Gesso is my favourite primer, but you could use household primer at a push.

Canvas

Canvas nowadays is more often than not a cotton duck fabric, and comes in a variety of weights. The most common weight is 10 or 12oz., which is perfect for our needs in this book. Another favourite of mine is linen canvas, which has a heavier texture that lends itself to larger, more expressive works.

Your local shop will be able to supply you with stretched canvas, where the material is pulled taut over wooden stretcher bars, ready to paint; or canvas on a roll, which you will need to stretch yourself (or have a professional do it for you). The advantage of canvas on a roll is that you can dictate the size of the finished work.

Canvas board

Canvas board is fabric stretched over greyboard. It is primed and ready for use. These boards come in many, many different sizes, and are slightly more stable than fabric stretched over a frame. This helps with very textural pieces – stretched canvas can bow under the weight of substantial texture, or even rip if you are slightly over-enthusiastic with a palette knife!

Paper

Like canvas, there are several different types of paper that can be used for abstract art. Here are some brief notes on the types of paper used for the projects in this book.

Water colour paper

This comes in several weights and finishes. A good starting paper is a 425gsm (200lb) Not finish 100 per cent cotton paper, but you should experiment to find your preference.

Lighter-weight water colour paper; that is anything less than 425gsm (200lb), can buckle if too wet, so you may wish to stretch it before you start.

Acrylic and pastel paper

There is also paper widely available that is designed with to work especially well with acrylic paint or with pastels.

Pastel paper tends to have a medium-to-fine tooth, which means the pastels adhere well whilst leaving the gaps that make the medium so appealing and luminous.

Acrylic paper sometimes have a canvas-like weave and are primed ready for use. This makes them ideal for acrylics, but not so useful for water colour work, as it may repel the paint.

Tip
While canvas is often associated with oil and acrylic paints, with the correct primer (gesso), you can apply water colour, gouache and other media. Pastels are particularly effective on canvas.

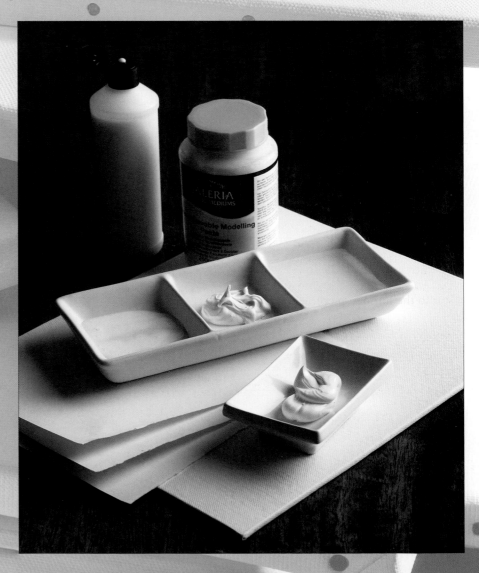

Changing textures

You may wish to experiment with altering the basic texture of the surfaces, to achieve certain effects. Here are a few methods of doing so.

Water

The simplest and cheapest method of altering the properties of water-based media such as acrylic, gouache and water colour paints is to add water. This thins the paint, increasing the flow and reducing the intensity. It also means that you can achieve certain effects, such as spattering and glazing.

PVA

A water-based adhesive, this is the artists' flexible friend. This can be used as a medium; giving an elasticity to colours; as a primer, giving a smooth finish to the surface; as a varnish, protecting the finished piece and giving a satin semi-gloss finish to your work; and as glue, enabling you to attach materials such as gold leaf to a painting.

Texture gels

There are various type of texture gels, which work really well with acrylic paint. Colourless, these can be applied with a palette knife or other solid object (such as a CD or your hand) to any of the surfaces described opposite, where they create different structural, modelling or textural effects.

I like the effect that carvable modelling paste gives a surface, creating smooth or ruffled peaks and troughs that can quickly suggest shapes and form that can get your ideas and creativity flowing. It dries relatively quickly, and this can be hastened with the use of a hairdryer.

Kitchen paper

Since the invention of kitchen paper, art has flourished! I really enjoy the effects that this readily-available material can produce.

Dipped in a dilute PVA solution, it can be moulded on the surface you are using into interesting shapes, much like modelling paste. Although it takes a little longer to dry, it is much cheaper and so you can experiment liberally.

Kitchen paper comes in a variety of types. Each will lend a slightly different result to the finished piece.

Gesso

This is a universal primer that can be applied to any surface. It gives a fantastic tooth that is easy to paint on and ensures that your media do not flake away or become absorbed by the surface.

I recommend priming twice with gesso: apply a dilute layer first, allow to dry, and then repeat with a slightly less dilute layer. This will ensure the surface you are using is thoroughly covered, making it perfect to bring your masterpieces to life.

Gesso is very rugged, and can be smoothed with fine sandpaper to give a flat finish: perfect for finer work.

Tip
Keep your water clean: this ensures the colours remain true and pure.

Tip
When using PVA as a size (a protective layer that seals the surface and prevents absorbency), dilute it with the same amount of water.

Tip
Dried texture gel or kitchen paper can look slightly grey. Luckily, a little titanium white will soon restore a pristine surface on which to begin.

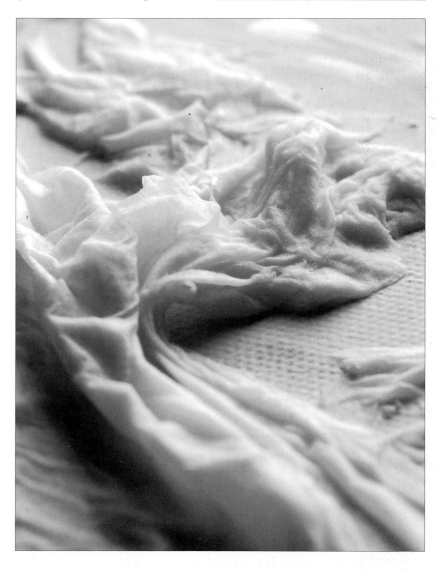

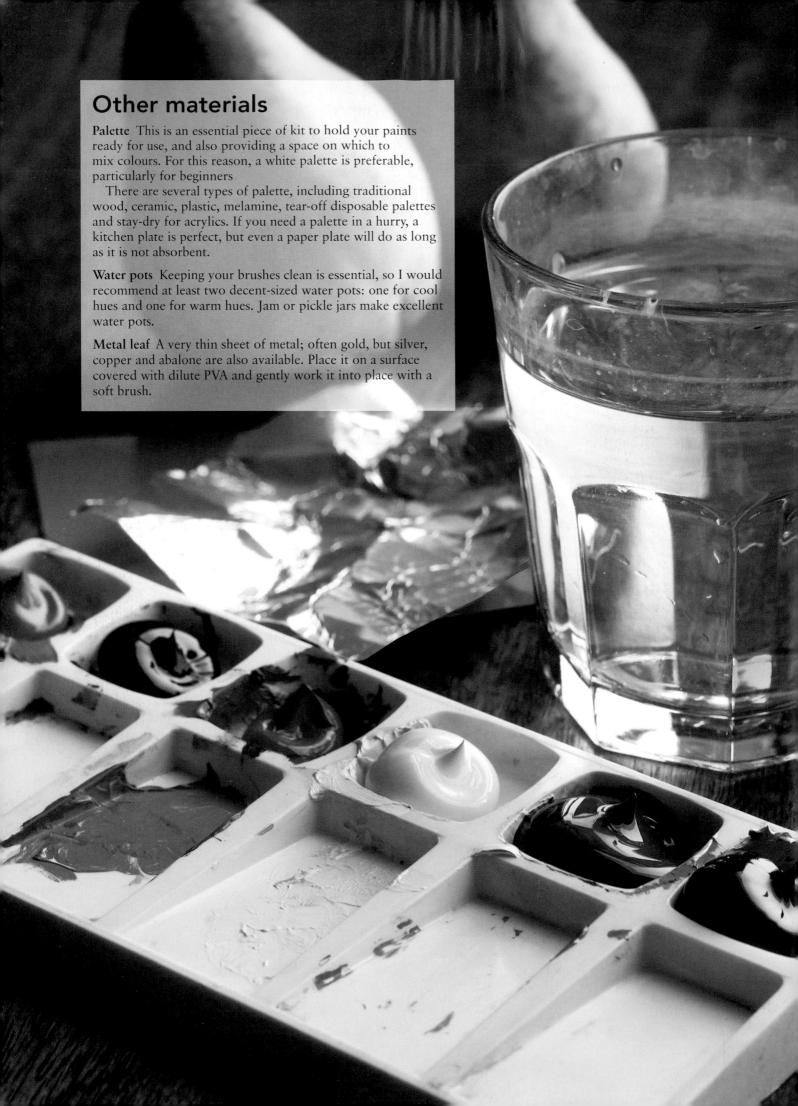

Other materials

Palette This is an essential piece of kit to hold your paints ready for use, and also providing a space on which to mix colours. For this reason, a white palette is preferable, particularly for beginners

There are several types of palette, including traditional wood, ceramic, plastic, melamine, tear-off disposable palettes and stay-dry for acrylics. If you need a palette in a hurry, a kitchen plate is perfect, but even a paper plate will do as long as it is not absorbent.

Water pots Keeping your brushes clean is essential, so I would recommend at least two decent-sized water pots: one for cool hues and one for warm hues. Jam or pickle jars make excellent water pots.

Metal leaf A very thin sheet of metal; often gold, but silver, copper and abalone are also available. Place it on a surface covered with dilute PVA and gently work it into place with a soft brush.

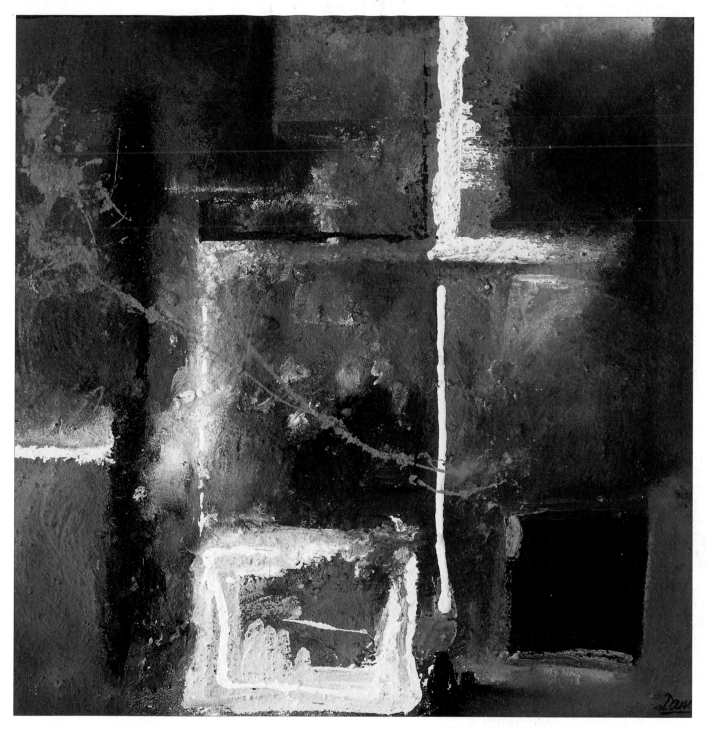

Jewels of the Madonna
60 x 60cm (24 x 24in)

Painted with acrylics on a board prepared with a sand texture, this piece takes its title
from a book seen in a library that really appealed to me. Inspiration can be found in the
darkest corner, so always keep your eyes open and your brushes at the ready.

Getting started

Moving from figurative work into abstraction can be a little intimidating at first, so these pages will introduce one method into abstraction, using a painting of geraniums as the starting point.

Composition

I have chosen to use flowers as my starting point because they have strong, appealing and easily recognisable colours. By changing the red of the petals and green of the foliage for an unnatural combination of orange and blue, and cropping in on a detail, we can quickly hide the origin of the image and begin to work towards a more abstracted piece.

Note that blue and orange complement one another, so that the image retains the attractive, appealing feel that caught my attention in the first place.

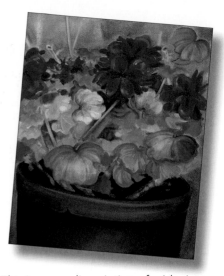

This is an acrylic painting of mid-winter geraniums, but feel free to use any source – photographs, a still life, or even the view from your window can be used just as easily!

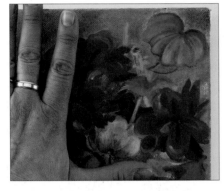

1 Choose a section that appeals to you; here I am using my hand to find an area with strong shapes.

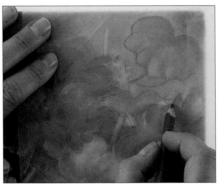

2 Overlay the area with tracing paper and draw round the main shapes with a pencil.

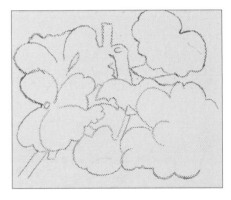

3 Transfer the shapes to a canvas board.

4 Paint the main shapes in bold, unnatural colours. In this case, ultramarine blue and pyrrole orange, with titanium white to tint.

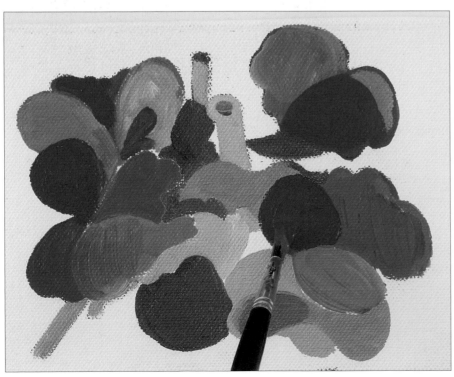

Tip
Making a pencil sketch of the original piece will remove the colour and help you to recognise the shapes and tone.

Abstracting further

Taking the slightly abstracted geranium picture as our starting point, a similar process is applied. In addition to changing the colours again (this time into bold primary hues), the definite, natural structure of the flowers is further abstracted into simpler geometric shapes, creating impact.

Turning the picture through ninety degrees takes us further from the original source. Compare the piece below to the original opposite: quite a change, and achieved with some very simple steps.

Tip

The original painting had the natural complementaries red and green, which I feel is the essence of the appeal. Therefore, keeping the colours strong and complementary is the main focus of this abstraction.

1 Referring to the abstracted version of the original, use a pen to draw a simplified version of the main shapes on some scrap paper.

2 Transfer the new shape to a canvas board, as before.

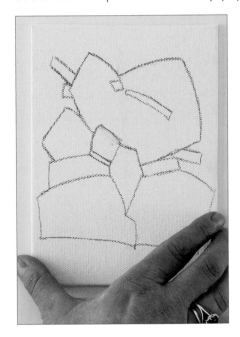

3 Turn the board ninety degrees clockwise. This helps to change your perception of the painting and leave the original source behind. It is also useful to change a landscape format picture to a portrait – or vice versa.

4 Paint in the main shapes using bold primaries: cadmium yellow medium, cadmium red and cerulean blue, adding titanium white to alter the tint.

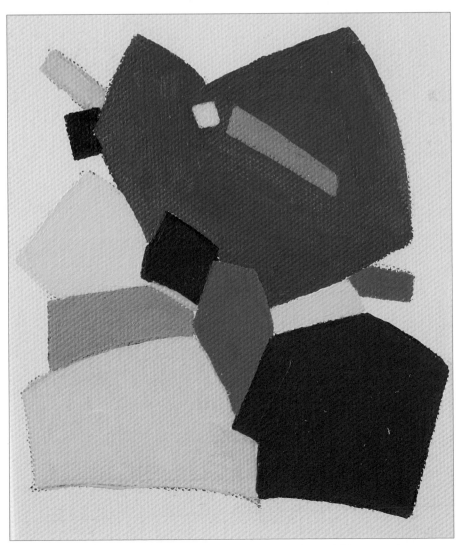

Texture

The texture of a piece can radically alter its impact. It adds dimension and can alter the weight of a piece effectively: lifting it with soft, light textures; or suggesting gravity and strength with heavier textures.

A surface with a strong textural quality (whether heavy or light) lends itself especially well to more expressive work because it tends to exaggerate, complement or conflict with the marks you make on the surface. It also gives the surface a three-dimensional quality that can either lead you, by suggesting shapes or areas to develop, or be deliberately ignored. This latter option can help you to create a discordant or cantankerous finished piece, where the texture of the surface is of equal importance as the strokes of the medium.

Spattering

An especially expressive technique, and one that is ideal for adding movement and vibrancy to a particular area. Because it only works with dilute paint, it is fantastic for suggesting a light, airy texture to your piece, adding no dimensionality and remaining nebulous and free.

Tip

Not a technique for control freaks, spattering is loose, expressive and fun. Although an element of control is possible, the risk of spattering going wrong may add a frisson of excitement and fun to your working. Enjoy it, but protect any favourite or finished areas of your piece with scrap paper before proceeding.

1 Load a sable brush with dilute paint.

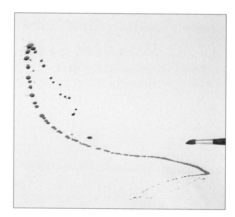

2 Use a sharp motion to flick the paint on to the surface.

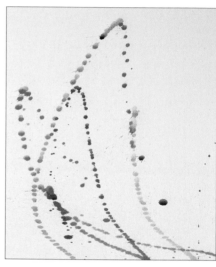

3 Repeat the process as required, and allow to dry. Spattering different colours in succession will result in the colours mixing while wet, producing a great effect.

The inverted spattering effect in the background here was achieved by spattering clean water on to still-wet paint. The area was then dabbed lightly with kitchen paper to lift out the excess water, creating a light area without compromising the texture of the canvas itself.

Inverted spattering (and simply lifting out paint) is a great way of creating highlights in your painting without obscuring texture. Less is more!

Using texture gel

Texture gel is useful for a variety of textures. Spread smoothly and with control, if can create a linear plane ideal for finer work. Spread more liberally and roughly, it creates a choppy, active surface. If you work quickly and with random strokes of the palette knife, you may be surprised by what images begin to suggest themselves.

1 Apply a rough blob of texture gel to the surface.

2 Scrape and flatten the gel across the surface to create ridges and peaks on the surface.

3 Add more texture gel if necessary, and allow to dry.

This strong, heavy and hard texture was created by adding some builders' sand to texture gel. Note the definite square shape: applied in one stroke and with minimal tweaking, a powerful texture was created.

This heaviness was taken into account with the painting: the red area surrounds and complements the stroke, while the overlaid lilac shape breaks into it without pushing all the way through it. Note that the lilac shape also mirrors the width and length of the textured stroke.

Colour

There are seven colours in the spectrum; but millions of subtle hues, which makes it a huge subject to consider. In terms of painting, a few definitions are useful to know, but do not be intimidated by the technical aspect: colour in abstract art can be as much about instinct as science.

Hue, tone and intensity

Hue is the term used to describe a specific colour. Duck egg blue and French ultramarine, are both blue hues. Tone describes the relative lightness or darkness of a colour. Tone can be altered by adding black or white; creating shades and tints of the hue respectively, or by adding other colours. Intensity describes the vividness of a hue – low intensity colours tend to look grey, while very high intensity colours are pure, vibrant hues. Slight impurities in paint means that mixing them tends to reduce the intensity, creating muted grey hues if too many colours are combined. This is why it is essential to keep your paints and water clean.

This can sound a little complex, so an example will help explain the theory. Adding ultramarine blue to alizarin crimson will darken the tone, alter the hue to a purple and reduce the intensity slightly. Adding cadmium yellow to alizarin crimson will lift the tone, alter the hue to an orange and also reduce the intensity slightly.

Balancing colours

Picking the colours to use in your palette for a painting is a good place to start. Using too much of one flat colour is boring! However, monotone work, where various tints and shade of a hue are used, can be very interesting. Whether you balance red against green; or ultramarine blue against cerulean blue, try to make sure that each complements the other.

Using colours to create effects

Some colours appear to advance: your eye is drawn to them and they seem to leap off the surface. Similarly, other colours are fugitive, and appear to recede. Reds, yellows and vibrant hues will advance, while blues, greens and more muted colours will recede. This can be used to draw the viewer's eye to a certain area or to create the illusion of distance.

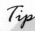
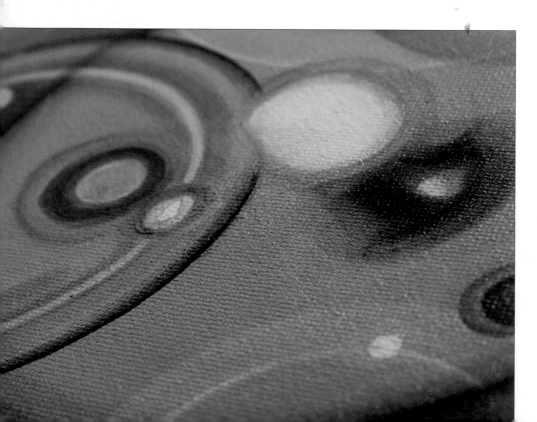

This detail shows the central white element of the painting opposite. Acting as a light source, this vibrant light-tinted area is eye-catching. This provides a visual anchor for the viewer.

From this central point, the eye roves over the other areas, taking in the warm red hues, then the cooler blue background.

Because the element is central and surrounded by a complete circular element, a sense of safety and protection is created, evoking a positive response to the work.

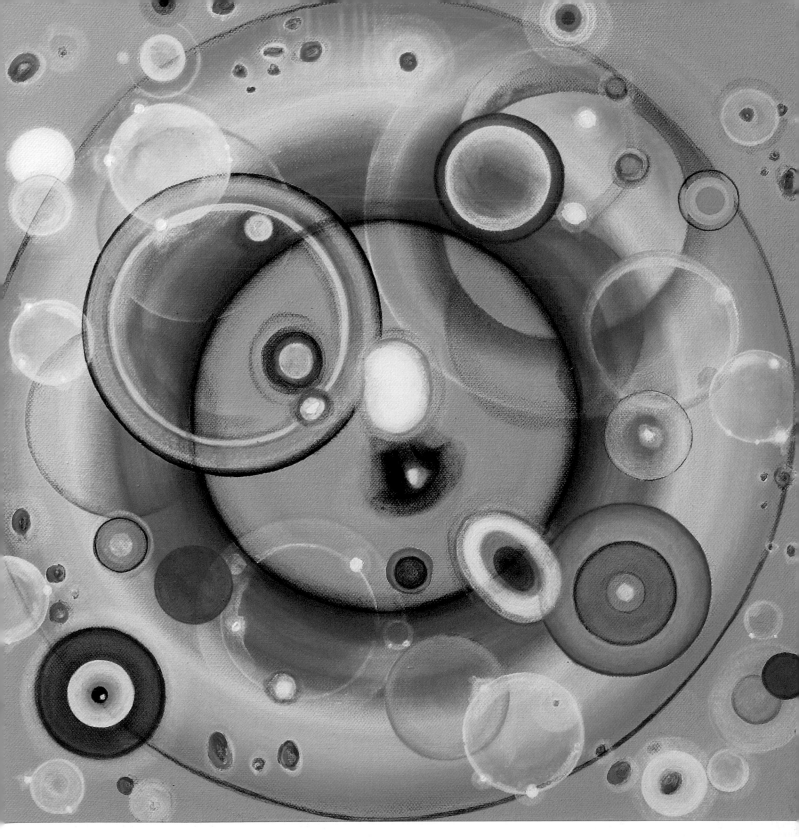

Light Fantastic

40 x 40cm (16 x 16in)

The circular motif used here was inspired by a magazine article on 'space bubbles' as seen through the Hubble telescope. I wanted to capture the sense of otherworldliness, so I used multiple glazed layers. Glazing is the application of dilute mixes of paint over existing areas of colour. This changes the hue of the paint beneath, but maintains the vibrancy of both. A yellow glaze over blue will create green, and white will create a pastel.

Note the large circular element. The juxtaposition of the warm, advancing, dark red inner part with the cool, receding, light blue-green outer part creates a pulsating image as the eye moves – essential to the overall success of the colour and tonal balance in this painting.

Light and clarity

Light is an important part of abstract painting, whether literal or symbolic. Light tints catch the eye and so appear larger than they are, while dark shades do the opposite. Having too much of either will unbalance the painting – and poor use of tone can create a dull finished picture.

To avoid this, balance light areas with dark areas as you work, adding different tones and continually checking the colour balance by eye. If it looks too dark, add a light area. If it is too light, add a dark element. Tints and shades should be balanced in the same way as colours.

Leaving space

A painting with a large amount of space can create a relaxed feeling, while a painting with many elements and little space can create a safe or secretive feeling. However, an overcrowded painting can create a claustrophobic, busy feel in the viewer, while an overly open painting can create a lost or isolated feel. The amount of space you choose to leave is therefore an important part of the finished piece.

Some artists may deliberately leave very large areas clear areas as a statement, so do not be afraid to leave some breathing room for the elements you choose to emphasise.

Light source

In a figurative painting, the light source is often obvious: the sun. Highlights therefore tend to be on the top of objects, and shading below. In an abstract painting, this is not necessarily true. The light source can be imagined and symbolic, and can be on the canvas, or off the canvas.

The important thing is that there is a source of light, however small, and that the tone of the elements (or objects) in the painting refer to it – i.e. highlights are on the side nearer the light source and shading on the side further away. Of course, this can only be a guideline: you may wish to deliberately have the highlighting and shading of an object bear no relation to the light source to create a particular effect.

This detail shows the bright yellow centre of the painting opposite. Note the striped area at the bottom right, where the colours seep and are reflected back towards the source.

This border around the light source helps to root it, and prevents the big yellow area from becoming too dominant and making the finished painting too open, flat and dull.

Apple Aurora
23 x 30cm (9 x 12in)

This painting is a perfect example of light and clarity: a large yellow area in centre acts as a light source, casting highlights on to the top of the figuratively-painted apple, and lowlights on the bottom.

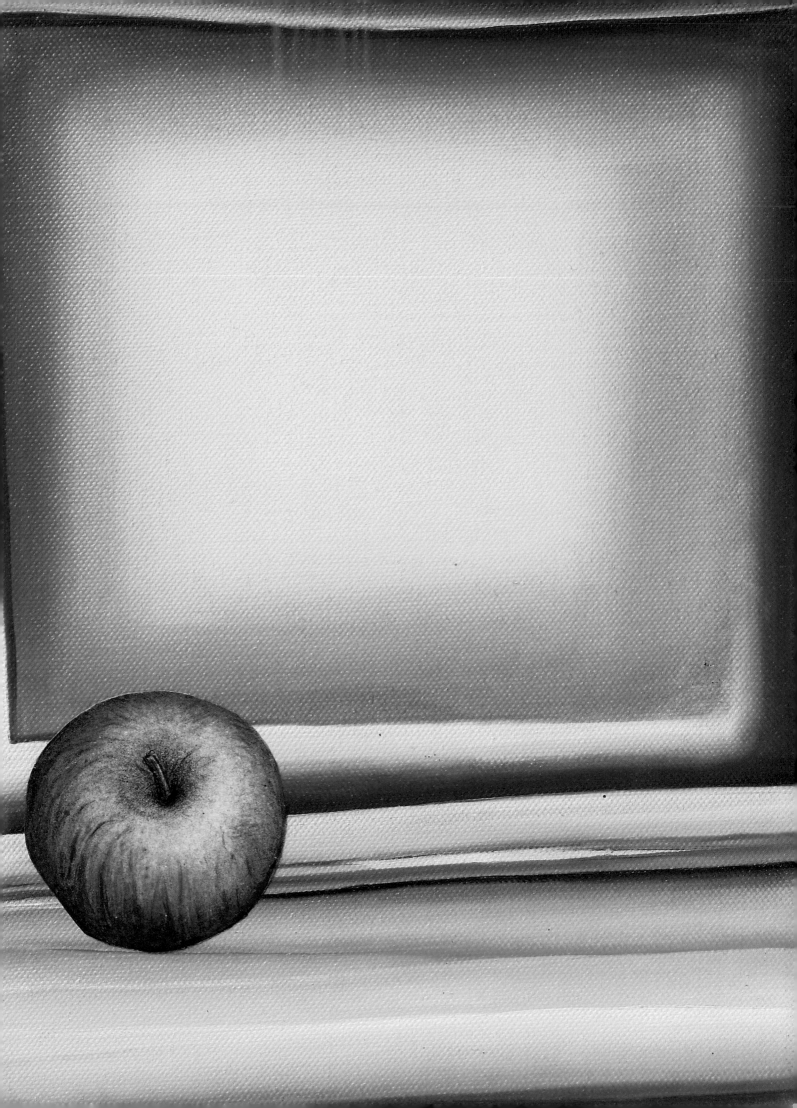

Imagination and exploration of emotions

Figurative or realistic art tries to recreate or represent actual physical objects, which means that the emotional effect it has on the viewer is affected by the associations the images have on the individual.

In contrast, abstract work can go straight to the feelings of the viewer, and have an immediate emotional effect. This is one of the most appealing and fun parts of abstract painting, and is definitely worth exploring and enjoying.

Symbol and sign

Where figurative art might represent the sun as a bright yellow circle, a symbolic interpretation of the sun might be a large red square used as the light source; or simply shown through the colour palette you choose. The important point is that the concrete physical object can be represented by a symbol.

Think about how the feeling of sadness might be represented symbolically: perhaps a muted palette of greens and blues or dilute paint drawn vertically down the surface to represent tears. Similarly a close friend might be represented by a geometric shape in the centre of your work, with their personality represented by the colour of the shape.

There are quite literally no rules on symbology: let your intuition and imagination take the lead. Return to the suggested ways of balancing colour and tone if you need a refresher or to move on from a strong first symbol that has left you stuck for inspiration.

Combining fantasy and reality

The painting opposite is a great example of how the realistic (the pear) is contrasted with the symbolic (the rings), which creates a surreal image with a touch of humour.

Adding realistic elements to your work can create positive tension between the easily recognised and familiar object, and the unfamiliar symbolic shapes – allowing the viewer a safe invitation to begin interpreting what might be an otherwise challenging picture.

Never be afraid to put a little humour in your work: use your personality to drive the painting. If you are intense and driven, tell the viewer about that; and if you are dreamy and laid-back, bring that to your work.

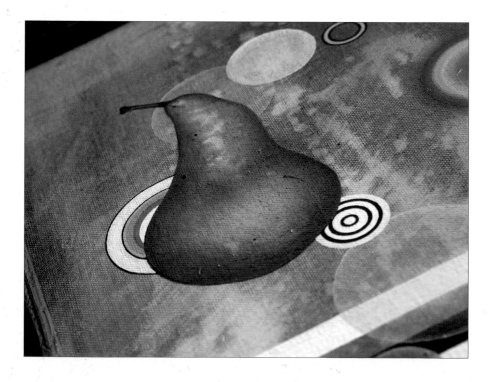

Note the smaller elements behind the pear, which stop it from blending too much with the background. The rings echo the pear's shape, which helps to tie it in to the rest of the painting and prevents it from simply appearing separate or unrelated.

The rings across the painting are all related, but none are as striking as the principal elements of the red ring and the pear.

Cosmic Pear
30 x 40cm (12 x 16in)

The red ring symbol on the right is eye-catching and obvious. The pear is painted in muted tones similar to the background to offset the natural tendency to focus on the easily-recognisable object.

This creates a balance: a simple shape with eye-catching colours against an everyday but muted image.

Integrity and meaning

A painting must have meaning beyond its initial impact, or it is simply decorative. How complex a meaning you want a painting to have is entirely up to you. An abstract might show an event from your childhood – or even your whole life; or it may simply be memories of a beautiful sunset.

Reading a painting

When reading a book, you read from left to right, and top to bottom. A well-executed painting will draw your eye from point to point, using ending up near the centre rather than leading the viewer's eye off it.

Colour and tone can be useful here – a large bright yellow shape will catch the eye immediately, making it the first point of reference. Putting it at the bottom left, with a bold green shape above it and a muted dark violet shape to the right will draw the viewers eye in a particular shape.

If an artist wants you to read a work in a particular way, he or she will place a particular colour or shape somewhere for the eye to find. This can be very deliberate, and may relate to symbols personal to the artist, as discussed earlier. As an artist, you may wish to help the viewer in this way or not, dependent on the message you want your artwork to create.

Creating narrative

While figurative artists generally have a particular interpretation in mind for their painting – a horse jumping a stile, or a relaxing sunset – abstract art can be much more open. In fact, abstract artists have often left their compositions untitled, allowing the viewer to interpret the painting how they wish. Bearing this in mind, you might use the ideas we have explored in this section to suggest a particular interpretation of something from your life.

Artist as filter

The abstract artist often takes a complex experience, emotion or memory and simplifies or breaks it down into the parts which are of particular importance to them. They act as a filter, removing extraneous, unwanted or overly complicated material, and rendering it down to its essence – perhaps as pure colour, pure form, or a combination of the two.

This detail shows how vibrant colours like the red element on the left can be muted by glazing and overlaying techniques, making the element softer and less eye-catching, ensuring it does not detract from the main elements, despite being a warm, advancing hue.

Venice
25 x 30cm (10 x 12in)

My inspiration was taken directly from the impression of the Murano glass I saw in many shops during a visit to Venice: bright, vibrant and eye-catching.

Your eye is led from the red square on the top left in a curve through the bold purple square to the small yellow element, and from here the direction is less obvious: the eye is free to roam over the rest of the elements. This neatly represents the narrative of seeing a particularly eye-catching piece of glass while walking past, then slowing to look at the more subtle pieces at leisure.

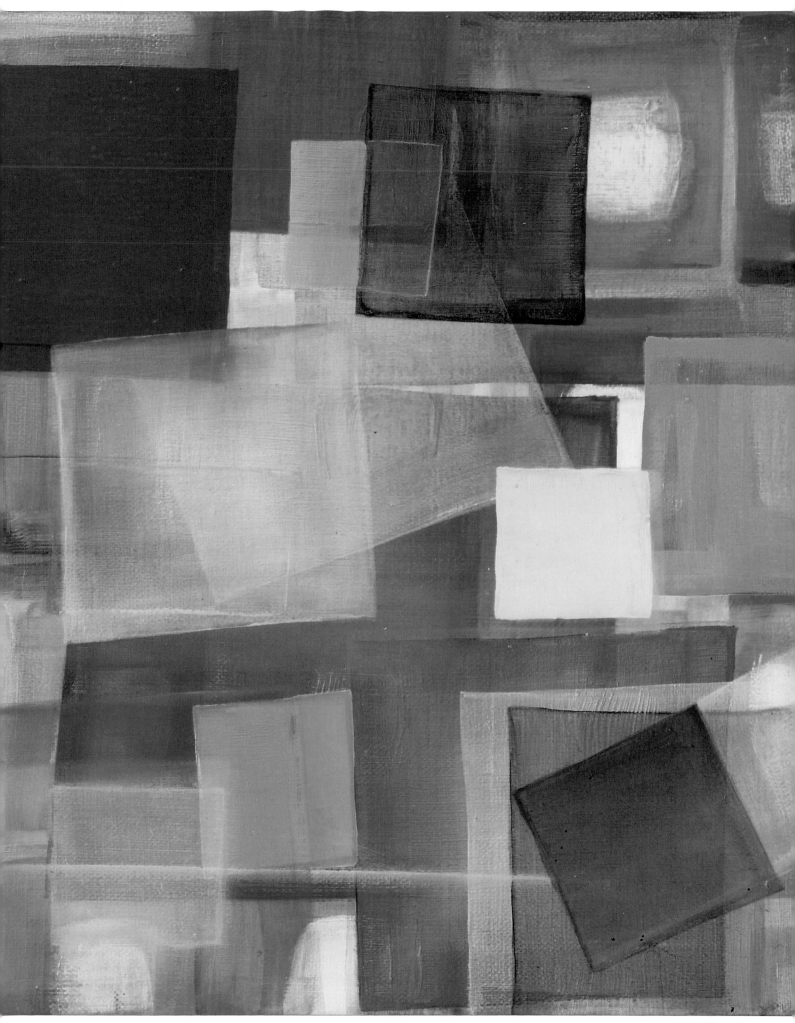

Using your other senses

While sight is the most obvious way of working with paint and abstract art, it can be useful to call upon some of the others. Touch can be represented by texture and sound can be represented by a rhythmical use of colour, as shown in the painting opposite.

Rhythm and repetition

Linear strokes not only lead the eye for narrative purposes, they also serve to dictate the speed at which you look at different parts of the painting. Strong contrast in colour, or the shape and size of objects within areas can encourage the viewer to concentrate on certain areas, or give others a less prominent role.

Repetitive strokes and shapes can give a particular emphasis to certain areas, reinforcing an underlying narrative message. In the painting opposite, the shapes in the central area are more similar to each other than the shapes at the top and bottom. Similarly, the red hues of the middle row are closer in hue and tone than the oranges and yellows of the bottom and top.

Elements

'Element' is simply a way of describing an object or area of interest in an abstract painting; such as the pear or rings in *Cosmic Pear* on page 25; or the individual squares of *Colours by Number* opposite.

The elements in the red row of the painting opposite are the smallest because the colour is so eyecatching, while the colour of the purple row near the top is more muted and fugitive, so the elements are given more space. Each of these rows is an element of the finished piece in its own right, echoing each other.

Tip
Art is often described in terms of music – colours 'harmonise' or are 'discordant'. It is worth noting this idea, as music is often a great inspiration. The artist Joam Miró gave some of his paintings titles inspired by music.

This detail shows the rows in more detail. Each horizontal coloured element is split by light-toned vertical strips, and glazes of various weight were then applied to the individual elements of colour this created. The subtle differences in hue create a playful jazzy rhythm.

Colours by Number
30 x 40cm (12 x 16in)
This painting demonstrates how placing contrasting colours near each other reinforces the hues. The black and cream grid prevents the colours from overloading each other, and creates a strong, rigid feel to the painting which complements the busy and mobile colour scheme.

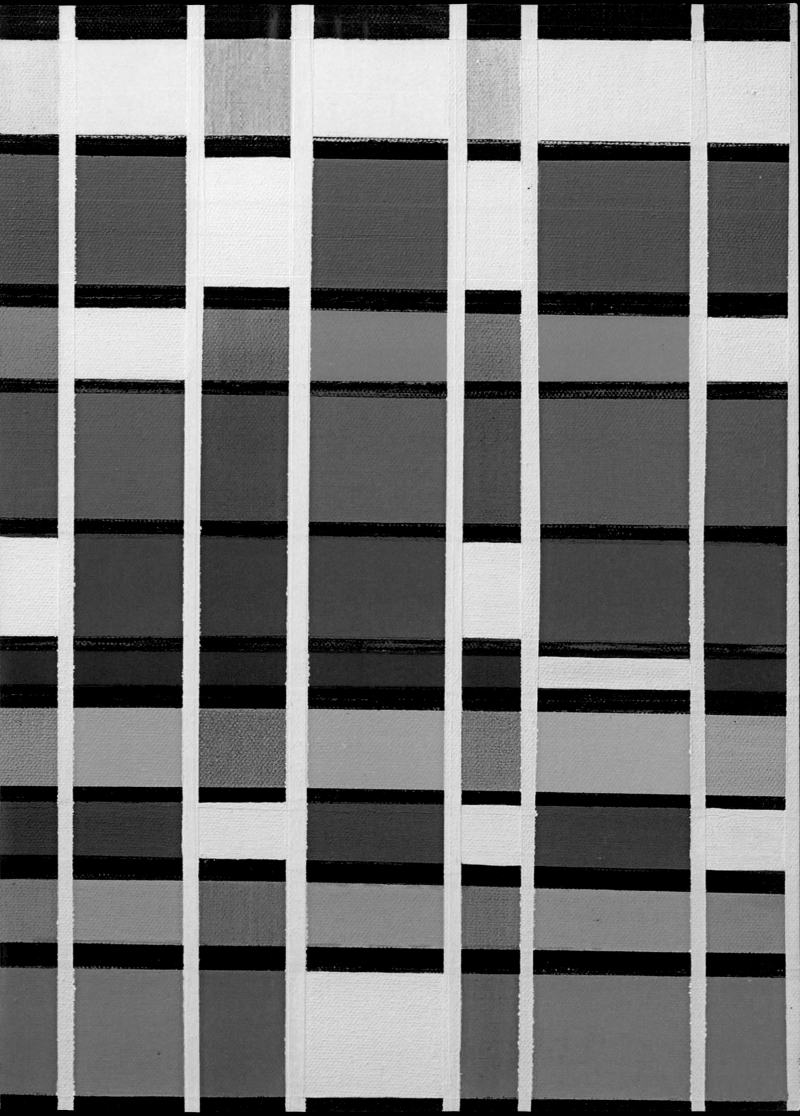

Demonstrations

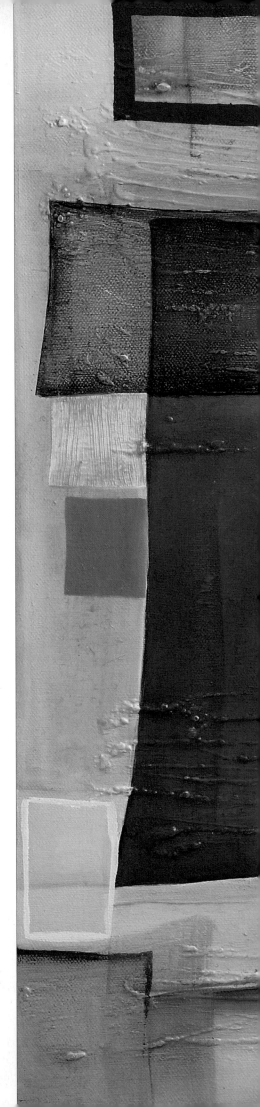

The overall aim of this book is to free you up as a painter and to help you think differently about how you work and from where you draw your inspiration: in essence, to help you find your own voice as an abstract artist.

I would also like to allay any fears of abstract painting with this book: abstract art provides so many options for exploration that it can be hard to know where to start. Following these projects is a good way to practise the practical aspects of abstract art and have some work behind you before you start your own compositions. Think of this book as the high street – it provides all that you should need, and is always there for you to return to if you get lost, but half the fun is exploring the sidestreets and back alleys of art on your own.

I have used squares and circles as the principal elements for these paintings. These geometric shapes are universal, and also have an architectural quality; in Palladian architecture, with its structure and straight lines, for example. The imagery of circles within squares (and vice versa) of the mandala in Buddhist symbology was a subtle influence on my work. However, there is no reason these elements could not be substituted for something else using the information on pages 20–29 to guide you – architecture, beliefs and philosophies are great sources of inspiration if they are important to you, but something frivolous like the smell of fresh bread or a bar of chocolate can be just as useful to get your muse going.

With all that in mind, take a deep breath and have a go – what have you got to lose? Be adventurous, be brave, and have fun.

A few final tips from one artist to another:

- Stand whilst painting if at all possible. It gives a better overview and keeps your energy up.

- Do not let others pass comment or see your work until you are ready, and be prepared to smile indulgently if the reaction of your friends or family is less than completely supportive. You are painting for yourself, not them (bless 'em!)

- Have a glass of wine or refreshing cup of tea nearby while you work. A short break now and then will ensure that you do not rush the piece.

- Give yourself time to paint: do not try and squeeze all of your creativity into a lunchbreak.

Dream 1
51 x 51cm (20 x 20in)
This piece uses warm colours and repetition of bold, simple shapes to give a dreamlike quality to the work.

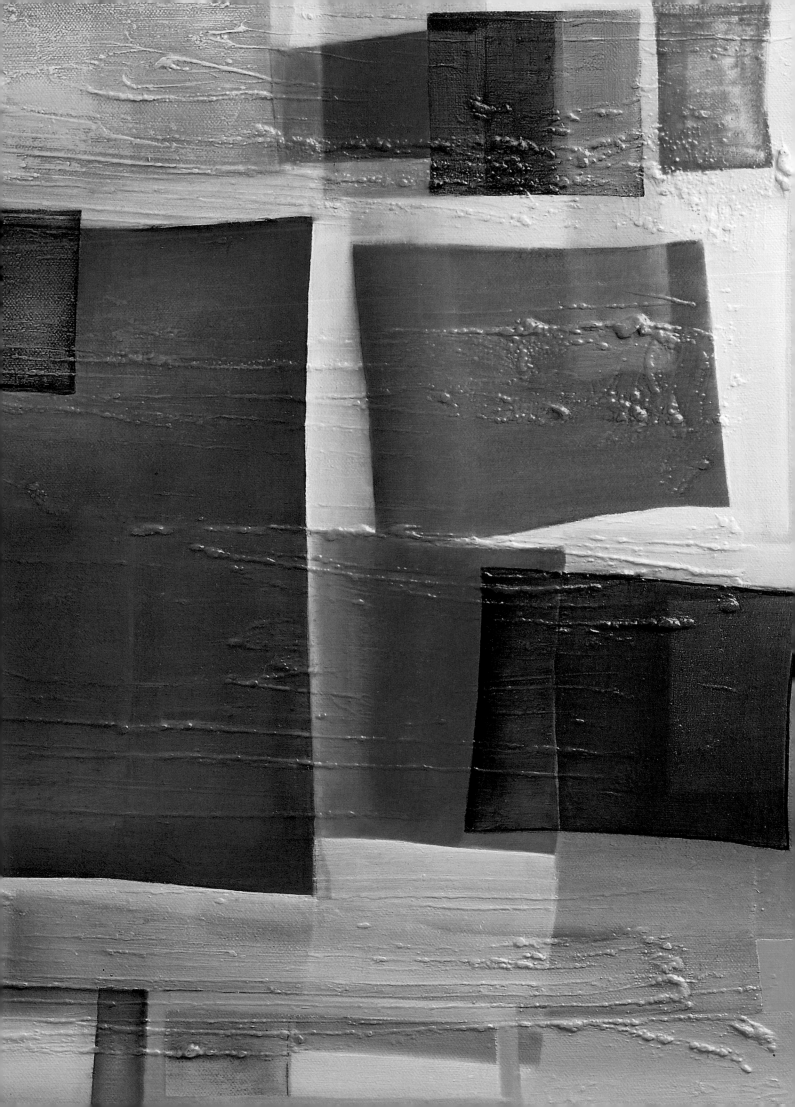

Sonnet

The process of painting this type of abstract is fairly organic. Rather than having a firm plan, you should aim to add shapes and colour in sections to balance the picture as it develops; being inspired by the shapes and colours you have previously applied.

I deliberately cover the board early on with bold, friendly colours in order to avoid the intimidating feeling of a blank white canvas!

This is titled Sonnet, as it is a short visual composition a little like a poem in colour. Like a poem, rhythm is very important, and this is shown through repeated use of square elements.

You will need

Canvas board 50 x 50cm (19¾ x 19¾in)

Acrylic paints: cadmium red medium, cadmium yellow medium, titanium white, pyrrole orange, permanent alizarin crimson, ultramarine blue, permanent rose, phthalo blue (red shade) and lemon yellow

Paintbrushes: size 14 Galeria short flat bright, size 12 Galeria short filbert

Pencil

Heavy carvable modelling paste

Small palette knife

1 Use a small palette knife to apply modelling paste to the board with broad, even strokes in a slightly random fashion. Leave the paste to dry overnight.

2 Squeeze some large areas of cadmium red medium and cadmium yellow medium directly on to the board, then wet a size 14 flat and brush over the daubs to create an underpainting (see inset).

3 Continue spreading the paint until the board is covered, then draw the brush evenly and gently down the board, working systematically. This will ensure the underpainting has an even texture.

4 We are now going to establish the principal element. Allow the underpainting to dry thoroughly, then use the size 14 flat to establish a rough square offset from the centre in titanium white. Dilute the paint just enough to allow it to glide over the underpainting.

5 Build up the square with more titanium white. Vary the shape and the consistency of paint when layering the sides to give a stronger or more broken line.

Tip

You can use flat bright brushes to create narrowing strips of colour. Use the broad side as you start the stroke, then gradually twist the brush until you are using only the tip to apply paint.

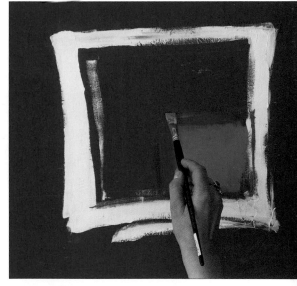

6 With the principal shape in place as an anchor, we can establish some further squares to echo it. Mix cadmium yellow medium with pyrrole orange and paint a square on the lower right of the principal square. Vary the tone by applying pure pyrrole orange to the left edge of the new square.

7 Blend cadmium red medium in to the edges of the inner square while the paint is still wet, then do the same with permanent alizarin crimson. This frame of darker tones at the edge of the square makes the centre appear to increase in vibrancy and advance on the eye.

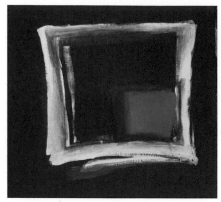

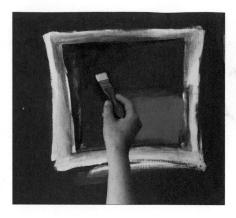

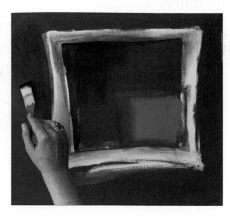

8 Still using the size 14 flat, Dilute pyrrole orange, cadmium red medium and permanent alizarin crimson, then apply glazing strokes of colour over the principal shape.

9 Establish some darker tones inside the principal shape with dilute mixes of ultramarine blue and permanent alizarin crimson. Concentrate on the left and top inside edges to provide visual balance to the square on the bottom right.

10 Apply a section of the same dilute mixes outside the principal shape. Use loose brushstrokes to develop the underpainting.

Tip
Glazing allows the colour underneath to show through, maintaining the luminosity while removing any starkness.

Tip
Using transparent colours like permanent alizarin crimson and ultramarine blue ensures that the underpainting maintains its vibrancy.

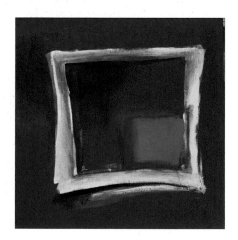

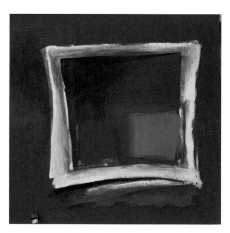

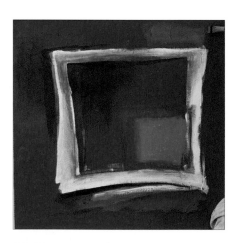

11 Apply more controlled strokes of permanent alizarin crimson and ultramarine blue at the bottom edge of the principal square.

12 Some highlights at the bottom left will make the picture sing. Tint ultramarine blue with titanium white then apply a vague shape here, adding more ultramarine blue to the mix near the top.

13 Use a mix of permanent rose and ultramarine blue to subtly introduce the colour at the top left, then use a mix of permanent rose and titanium white to block in a rectangle at the top right. Use pure permanent rose where it abuts the principal shape, and fade it out at the top.

Tip
Blue and orange are complementaries, meaning they each make the other appear more vibrant.

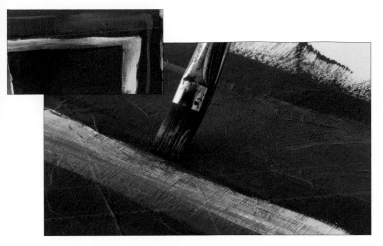

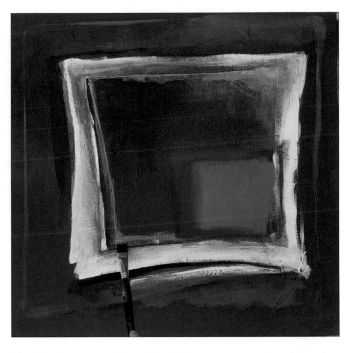

14 Draw strokes of the permanent rose and titanium white mix down the sides and across the top to frame the principal element (inset), then use a size 14 flat to drag the drying permanent rose at the base of the rectangle to create a feathered effect away from the principal shape.

> *Tip*
>
> Pink is a discordant (clashing) colour to red. Using it sparingly creates an exciting visual effect that grabs the eye.

15 Feather a small stroke of the permanent rose and titanium white mix at the base of the principal shape, then use ultramarine blue tinted with titanium white to add a feathered stroke inside the principal shape.

> *Tip*
>
> These strokes are subtle, but by keeping the combination of colours, shapes and brushstrokes you use in any one application unique, you are preventing obvious links or repetitions across the painting. This helps to keep the flow and narrative of the work free.

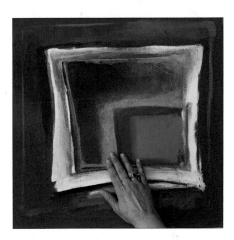

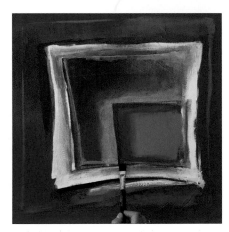

16 Feather a dilute mix of titanium white and cadmium yellow medium from the square on the bottom left. Feel free to use your fingers to draw out the paint.

17 Re-establish the edge of the square with fine lines of permanent alizarin crimson, applied with the size 14 flat.

18 Apply some squares of permanent alizarin crimson at the top left. Change the tonal weight of each by diluting the paint.

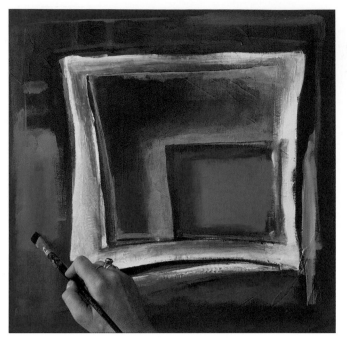

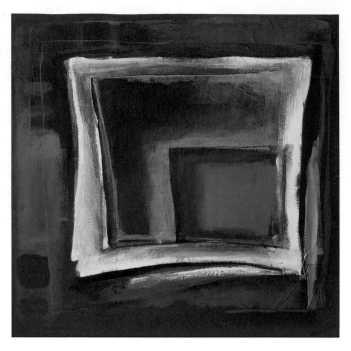

19 Apply glazing strokes of dilute permanent alizarin crimson to frame and contain the principal shape; then use a strong mix of cadmium yellow medium, pyrrole orange and titanium white to add strokes down the right. Add a corresponding shape on the left with a slightly more orange mix. Add even more orange in the centre and blend the tones together while the paint is wet. Note the strokes above it, which echo the permanent alizarin crimson squares at the top left.

20 Make a grey-purple mix of permanent alizarin crimson, ultramarine blue and titanium white, and apply a rough brushmark across the top of the painting. Using the thin edge of the brush to draw the colour round the edge of the principal shape.

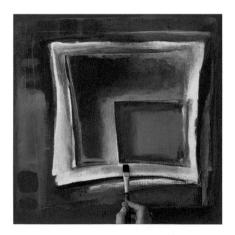

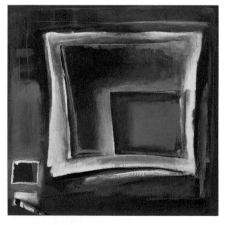

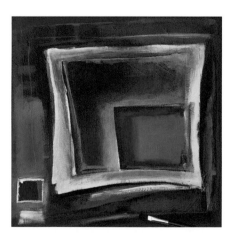

21 Add some light to the top right and around the inner square by feathering titanium white in these areas.

22 Echo the principal shape in the lower left with titanium white, then feather out the paint with your finger. Apply a simple stroke below the new square.

23 Apply phthalo blue (red shade) with the size 14 flat below the blue area, then add a smaller stroke of titanium white below that. Blend and feather the colours together using a clean size 12 filbert.

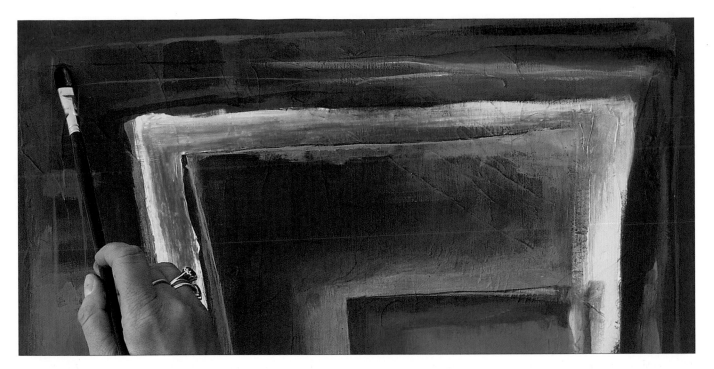

24 Still using the filbert with the phthalo blue (red shade), add a touch of white and suggest strokes across the top. Twist the brush as you work to narrow the lines towards the left.

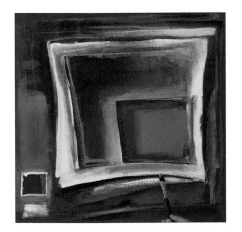

25 Make a light green mix from lemon yellow, phthalo blue (red shade) and titanium white. Use it with the size 14 flat to balance the light on the top and left of the principal shape as shown.

26 Use the mixes and colours on your palette to add some tweaks across the painting to balance it.

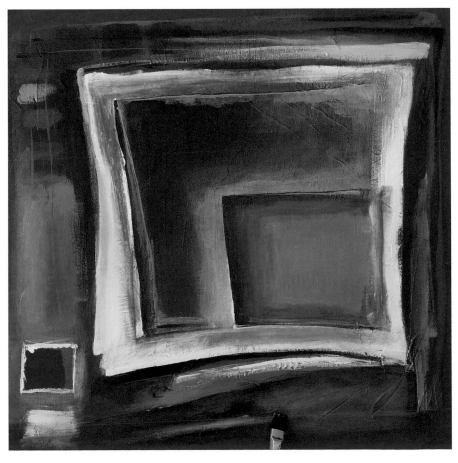

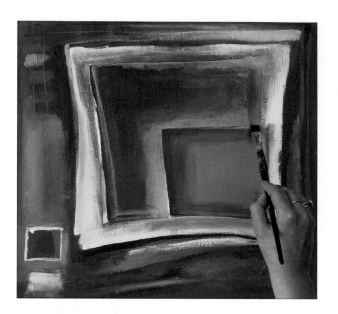

27 Switch to the size 12 filbert and feather an off-white mix of titanium white and cadmium yellow medium on to the main shape on the left, around the square on the lower right and to create a subtle rectangle below the square and on top of the blue stroke.

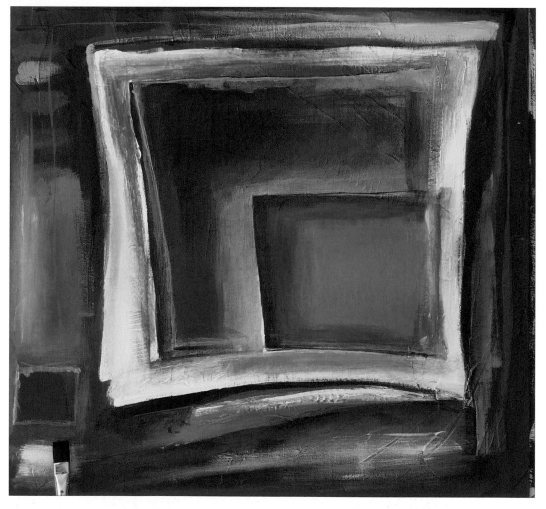

28 Knock back any areas that are too harsh with the yellow and white glaze, then use pure cadmium red medium to re-establish the inside of the principal shape. Use a fairly dry size 14 flat to apply a dilute glaze of permanent alizarin crimson to the square on the lower right to finish.

The completed project.

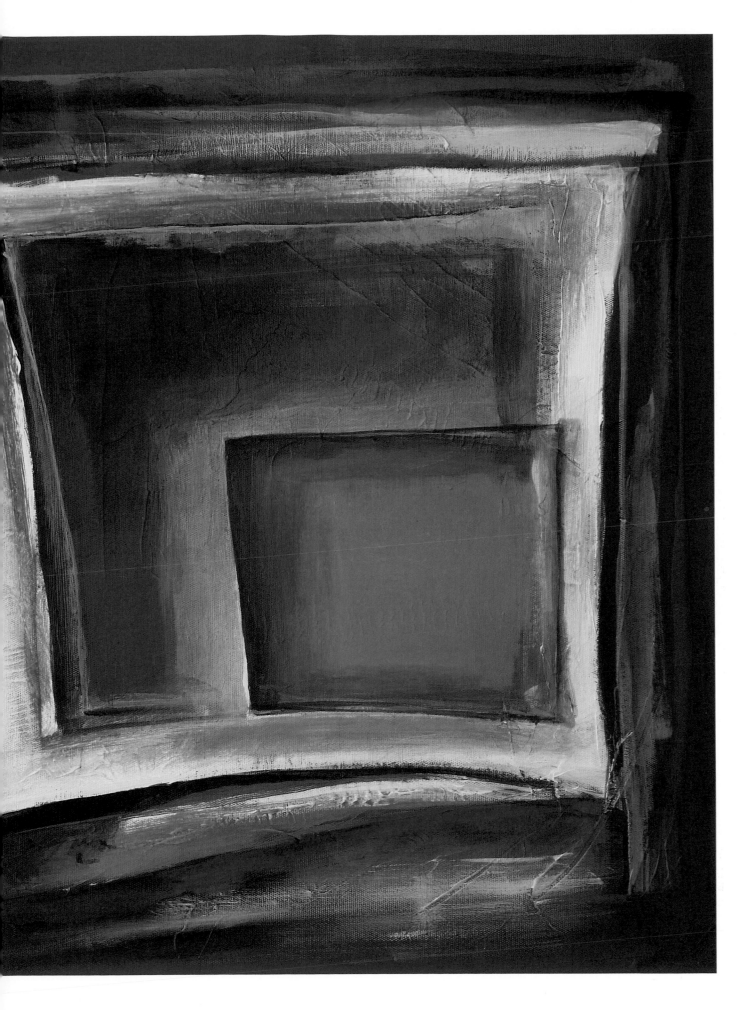

Spiritus

This is a piece that makes great use of texture rather than particularly bold colours. Kitchen paper is applied fairly randomly and freely, and the shapes it suggests leads our painting.

 Large square elements are painted over the top of the texture, suggesting a tunnel that leads to a smaller square in the background to create distance. The smaller square element is blue, a complementary to the overall warm orange used in the piece. As well as balancing the colour, this blue element gives the sense of an entrance to a mysterious other place, hence the title.

You will need

Canvas board 45 x 35cm (18 x 14in)

Acrylic paints: titanium white, raw umber, burnt umber, burnt sienna, pyrrole orange, cadmium yellow medium, yellow ochre and phthalo blue (red shade)

Paintbrushes: size 14 Galeria short flat bright, size 12 Galeria short filbert, Sceptre Gold II flat 2in, size 8 Sceptre Gold II round

Pencil

Kitchen paper

PVA glue

Heavy modelling paste

Small palette knife

Fork

Gold leaf

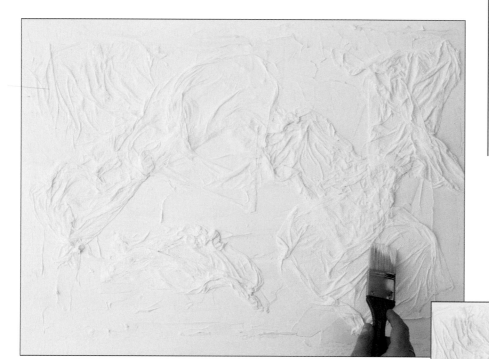

1 Apply texture paste using a palette knife and allow to dry. Next, mix equal amounts of PVA glue and water. Dip the kitchen paper in the solution and apply it to the surface in a fairly random fashion. Pull out areas that catch your interest and develop the random shapes into a series of peaks and troughs. Allow to dry, then use the 2in flat to apply a dilute wash of titanium white over the whole surface.

2 Apply a dilute mix of yellow ochre and titanium white over the whole surface in broken, patchy manner. This will capture the texture of the contours but allow some of the white to show through.

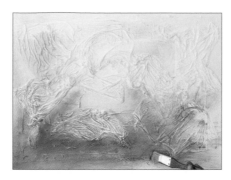

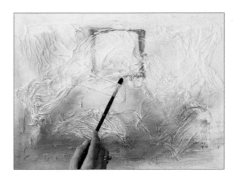

3 Add touches of burnt sienna and burnt umber to the mix, then continue to cover the board, applying a varied mix of colour. Keep the upper right fairly clean and concentrate the darker mixes on the lower left.

4 Switch to a size 14 flat and use a mixture of burnt sienna and pyrrole orange to introduce a stronger colour. Draw a fairly dry brush slowly and gently across the drying base coat to create a burnished effect.

5 Add cadmium yellow to the mix and develop the orange areas. Next, mix a bright burnt orange from cadmium yellow, pyrrole orange and burnt sienna. Block in a square element using the size 12 filbert and feather it out gently.

6 Add permanent alizarin crimson and burnt sienna to the mix and add subtle touches to develop the first element. Put a little titanium white on the filbert and feather the top left. This creates the impression of a light source to the top left.

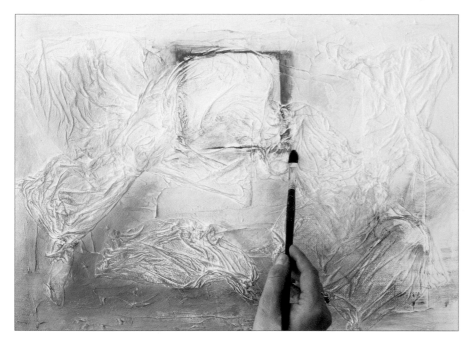

7 Use the filbert with a mix of burnt sienna and alizarin crimson to paint up to the edge of one of the raised contours on the lower right.

Tip
Allow the texture on the board to guide your brushstrokes.

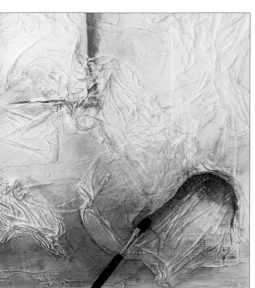

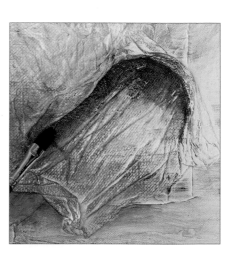

8 Develop and vary the contour with a titanium white and yellow ochre mix at each end.

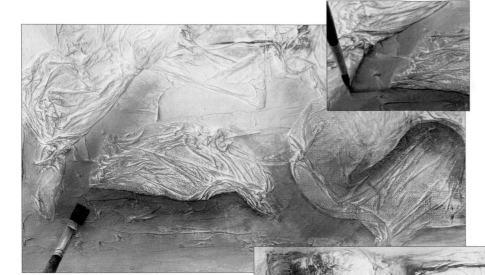

9 Switch to the size 8 round and use pure burnt umber to emphasise the shadows cast by contours on the lower left. Feather the colour down and to the left to blend it away. Link the contours with a stroke of burnt umber across the untextured areas of the board (see inset).

10 Using the size 14 flat, create a shape in the top left with burnt umber and raw umber. Apply the paint with a scrubbing action. This shape serves to balance the dark lower corner and link it with the square element in the upper centre. A touch of the same mix at the top right further increases the harmony of the overall painting by suggesting a rough rectangular frame for the eye to rest upon.

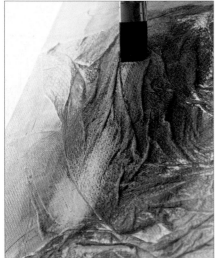

11 Develop a distressed, antique look by wetting the size 14 flat and lifting out some of the paint before it dries.

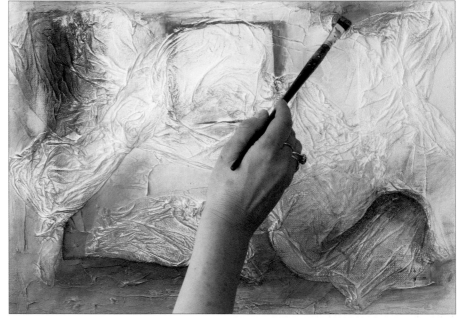

12 Add a thin wash of burnt umber and burnt sienna at the top right, feathering it away.

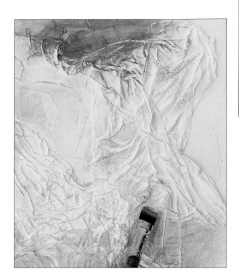

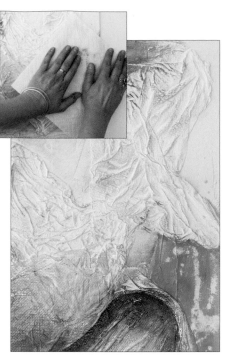

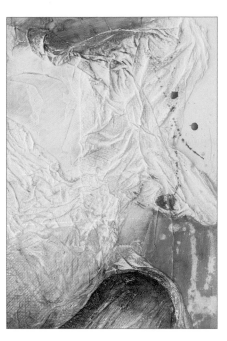

13 Before cleaning your brush, draw it over the contours at the top right. The remaining paint – and you may be surprised by how much there is! – will transfer to the upper ridges of the contours, creating a subtle but fabulous effect and leaving plenty of white in the recesses.

14 Use pure yellow ochre to mark in a stronger patch of colour on the right, using the contours to suggest and define the shape. Spatter some clean water on the area and place kitchen paper on it (see inset). Lift off the paper to reveal an inverted spatter effect.

15 Load the size 8 round with a very dilute mix of yellow ochre. Spatter above the inverted spatter effect with this colour.

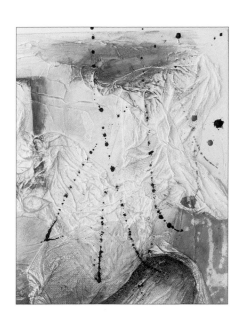

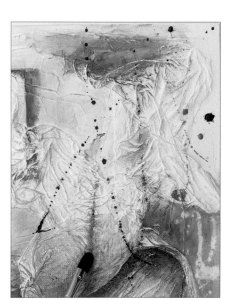

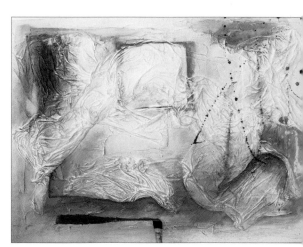

16 Spatter dilute burnt umber over the right-hand side of the painting using the size 12 filbert.

17 Use the size 12 filbert to loosely blend some of the spatters.

18 Balance the spatter with a twisted stroke of the size 14 flat at the bottom left.

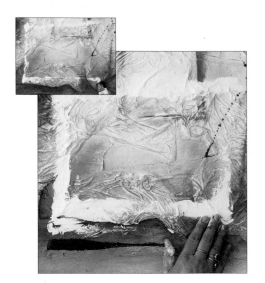

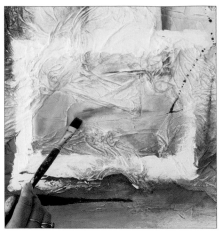

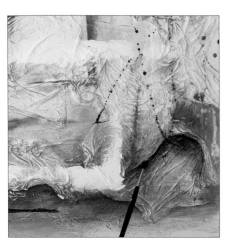

19 Make three sides of a square by squeezing a tube of titanium white over the centre. Apply the paint generously (see inset), then use a clean finger to massage the paint into the board to create a bold, stark central element.

20 Mix cadmium yellow medium with yellow ochre and apply to the inside left of the element and feather it into the centre, towards the light source. Vary the hue by adding cadmium orange.

21 Use the size 8 round to apply a bold feathered stroke of permanent alizarin crimson on the right of the element and to reinforce the lower right contour.

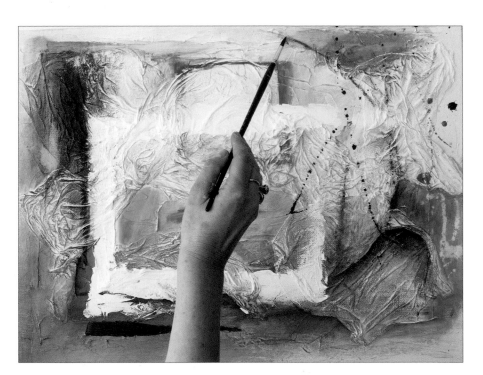

22 The contours suggest a curve on the right, so develop and reinforce this idea by drawing a loose stroke of permanent alizarin crimson on the right-hand side, using the tip of the size 8 round.

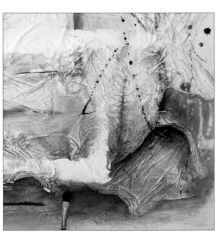

23 Use the size 12 filbert to apply feathered strokes of cadmium orange below the central element. These echo the lighter tint in the middle of the element.

Tip

This stage relies on the shapes suggested by the initial contours. Obviously, your base texture will vary, so it is important to rely on your own eye to pick out areas of your board you wish to accentuate. In fact, this is something to bear in mind with all of your abstract work, as letting your painting inspire you as you go will always generate great ideas as you progress.

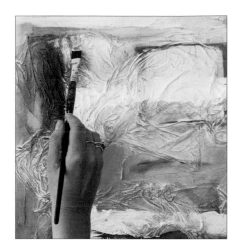

24 Balance the strength of colour in the lower right by add soft feathered strokes of titanium white in the top left.

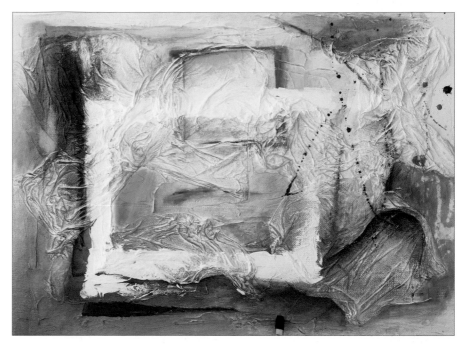

25 Make a mix of phthalo blue (red shade) and titanium white. Feather the colour out from the inner top left corner of the orange element, then paint a stroke at the bottom of the picture to balance it.

Tip
The addition of the blue streak leads the eye through the painting, from the strong, hot lower right, up through the stark central element, then into the more subtle orange element and out through the cool but strong blue corner. This creates a curve, echoed by the alizarin crimson arc on the right.

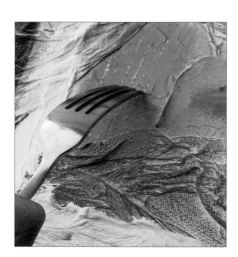

26 Use the tines of a fork to scrape out some of the dry paint across the picture. Concentrate on the areas without kitchen paper to avoid scraping away too much.

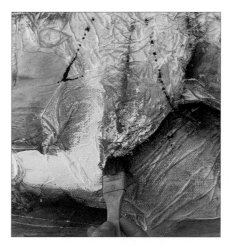

27 Mix up some PVA and water and apply a little of the mixture to the right of the central element. Lay a rough shape of gold leaf over it, then use a soft brush to gently press the gold into the contours and brush some of it away.

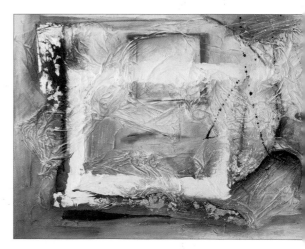

28 Apply more gold leaf in the same way over the rest of the painting, echoing the central element.

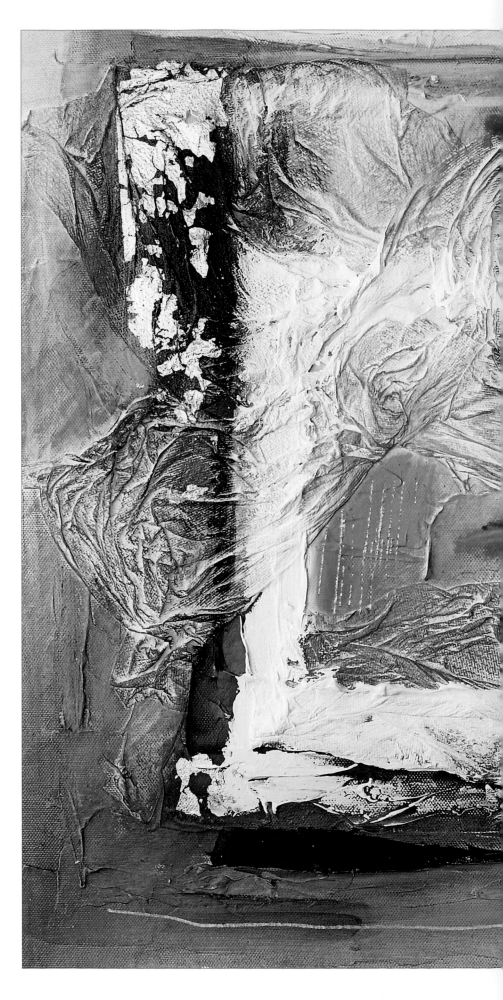

The completed project.

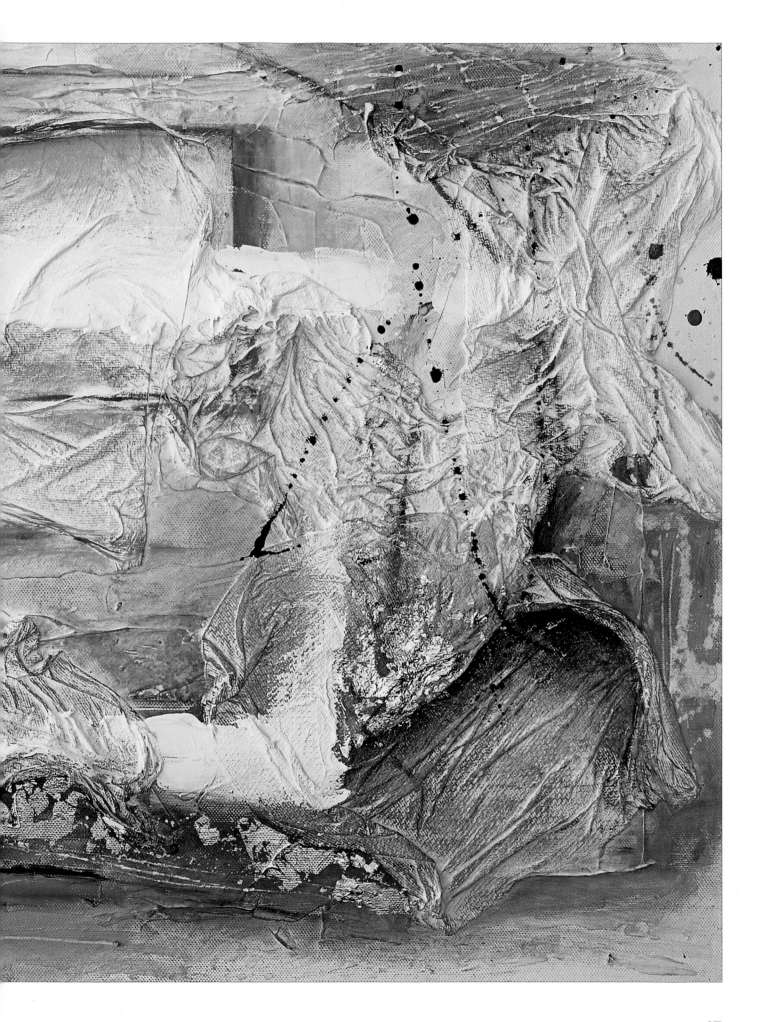

Echoes

Switching over to water colour and gouache paints, this painting will demonstrate how using different media together can work to create an exciting and fresh finish.

An initial grid structure gives a formal feel to the piece, but the loose use of water colours in the early stages brings a playful tension to the piece. Controlled application of the gouache, layered over the dry water colour restores some order, and strong contrasting black ink returns the grid to prominence.

The title refers to the use of more subtle pastel gouache hues layered over the initial bold water colour statements.

You will need

Waterford 300lb (638gsm) water colour paper 75 x 55cm (29½ x 21½in)

Water colour paints: lemon yellow, scarlet lake, yellow ochre, cerulean blue, Winsor green (blue shade), alizarin crimson and titanium white

Gouache paints: primary yellow, permanent yellow deep, spectrum red, primary blue, permanent green middle, yellow ochre and permanent white

Acrylic paint: permanent yellow deep

Paintbrushes: size 16 Sceptre Gold round, size 14 Sceptre Gold flat bright, Sceptre Gold II flat 2in

Wide-nibbed dip pen

Black Indian ink

2B Pencil

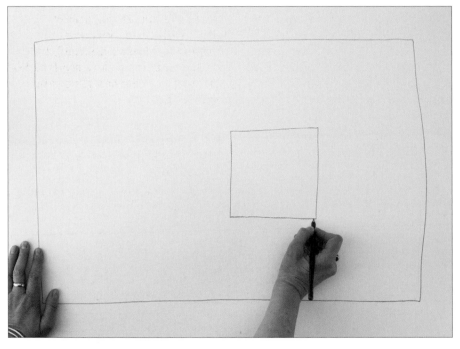

1 Use the 2B pencil to draw a frame roughly 5cm (2in) inside the edges of the paper, then draw a square just off-centre. This is to create an immediate asymmetry.

2 Lead off from this initial shape by extending the lines and creating a new element.

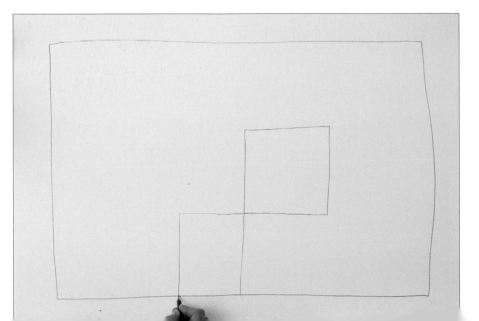

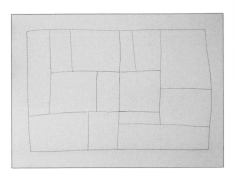

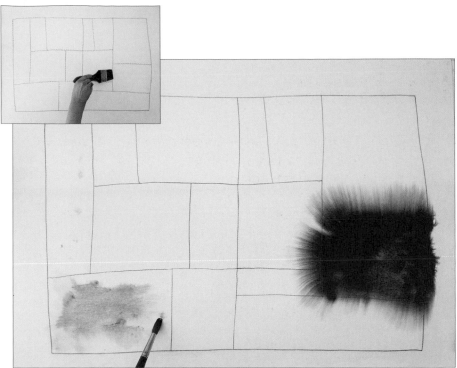

3 Create a fairly random grid of elements, extending some lines and creating new ones as you wish. Draw freehand – a slightly askew look will improve the feel of the finished piece.

Tip

The artist Paul Klee called this technique 'taking the line for a walk'.

4 Prepare wells of the following water colours: lemon yellow, scarlet lake, yellow ochre, cerulean blue, Winsor green (blue shade) and alizarin crimson. Use a 2in flat to wet the whole paper to a sheen (see inset), then use a size 16 round to apply the primary colours (lemon yellow, scarlet lake and cerulean blue) to some of the shapes. Start from the centres of the squares and allow the colours to bleed and merge.

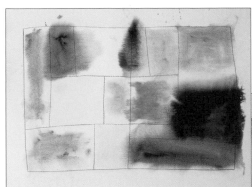

5 Apply the remaining colours in the same way, allowing them to bleed and merge into one another.

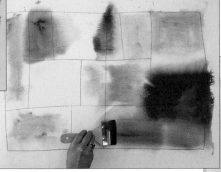

6 Draw a clean, soft 2in flat across the scarlet lake area at the bottom right to lift out some of the paint.

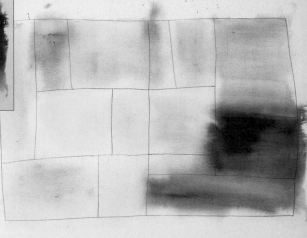

7 Clean the brush and repeat over the other areas, then allow the painting to dry completely.

8 Prepare wells of the following gouache colours: primary yellow, permanent yellow deep, spectrum red, primary blue, permanent green middle, yellow ochre and permanent white. Use the size 14 flat to apply primary yellow in a fairly structured rectangle over the lemon yellow areas of the underpainting. Do not cover the square entirely: leave some of the water colour showing to create an echo of the original shape.

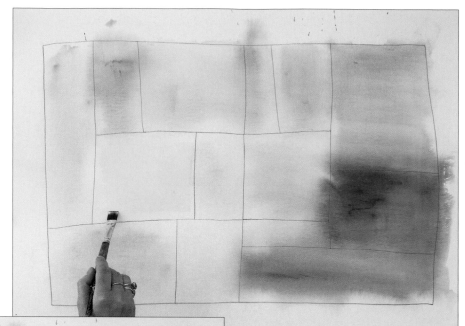

9 Apply the other gouaches to the corresponding colours: spectrum red over scarlet lake; primary blue over cerulean blue; permanent green middle over Winsor green (blue shade); yellow ochre over yellow ochre; and permanent yellow deep over areas where warm yellow has been created by reds and yellows have mixed in the water colour stage. Do not cover the whole of every element – leave some gaps.

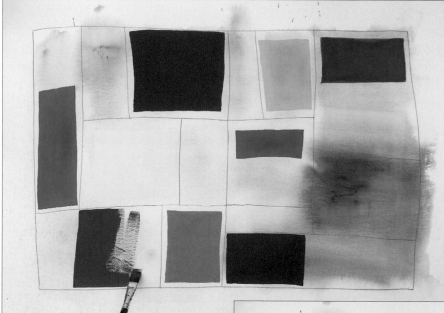

10 Add a little permanent white to each of the gouache colours to create pastel hues. Repeat the process of blocking in echoes of the purer-coloured blocks. This time, layer the colour either in the centre of the blocks or slightly offset as shown. Leave some of the edges a little ragged to contrast with the straight lines of the grid and elements.

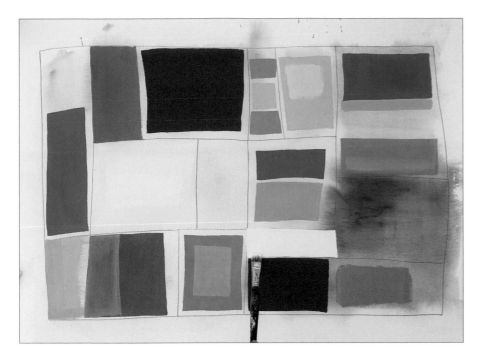

11 Apply some pure permanent white to one of the remaining smaller grid elements. This acts as a light source and lifts the overall balance between the light and dark tones of the picture.

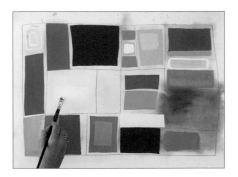

12 Add some other touches of permanent white as you please in blocks and hollow squares.

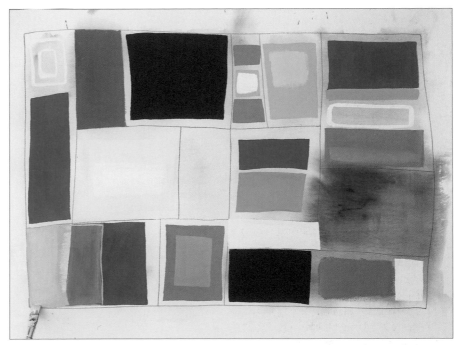

13 Place a precise white area next to the ragged-edged element on the lower right. This adds visual contrast and unbalances the overall picture by drawing the eye to itself. Balance this by drawing a square on the blue area in the lower left with a very light tint of primary blue (creating the mix by adding permanent white to the primary blue).

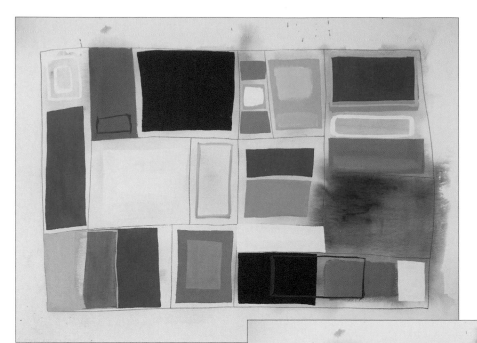

14 Add various amounts of permanent white to the original gouache colours and draw hollow squares over the painting.

Tip
Using a different tint of the original colour helps to link the original elements with their pastel echoes.

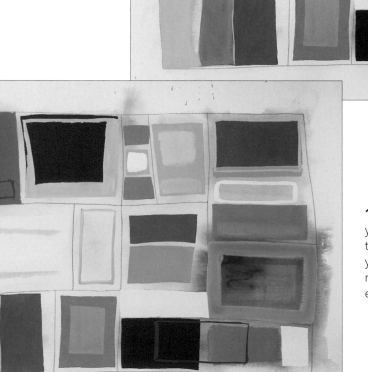

15 Start to 'cross-pollinate' the colours, using permanent yellow deep acrylic to draw a hollow rectangle on top of the red areas on the right and top.

16 Draw two strokes of permanent yellow deep acrylic mixed with titanium white acrylic across the yellow area on the left; and a thick, rough brushstroke on the blue element on the lower left.

17 Use all of the colours to create connections and breaks between the various elements with hollow rectangles and brushstrokes. Work freely, crossing the original grid, but maintain the geometric feel by keeping your additions to horizontal and vertical strokes.

18 Use a wide-nibbed dip pen with black Indian ink to reinstate the visible lines of the original grid.

19 Weaving the ink in and out of the shapes on the paper, draw some freehand hollow elements with black Indian ink to lower the tonal balance until you are satisfied that the overall picture is not too bright.

Tip
Work slowly through this final stage: you can always add ink – but you can not take it away!

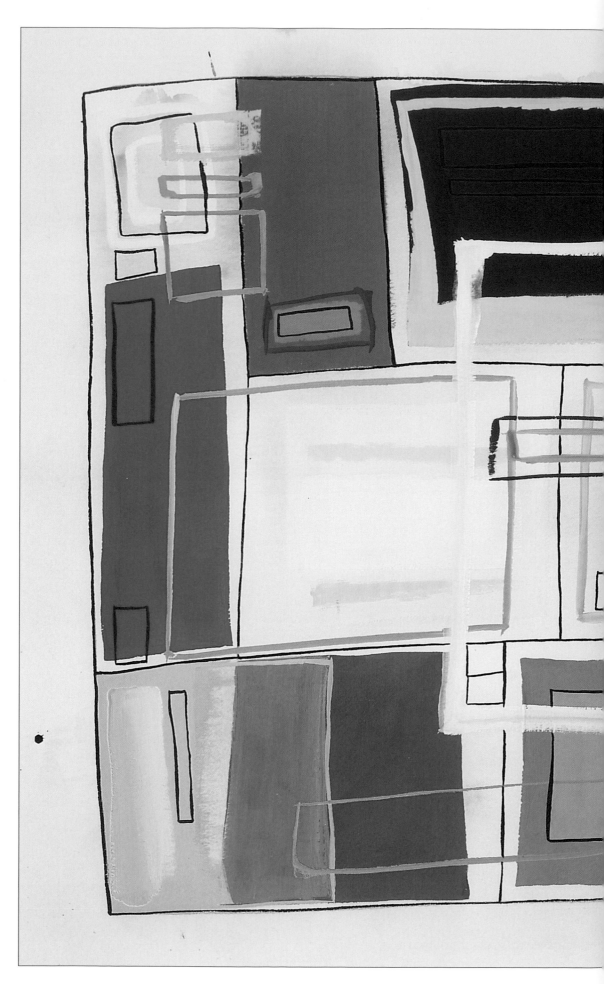

The finished picture.

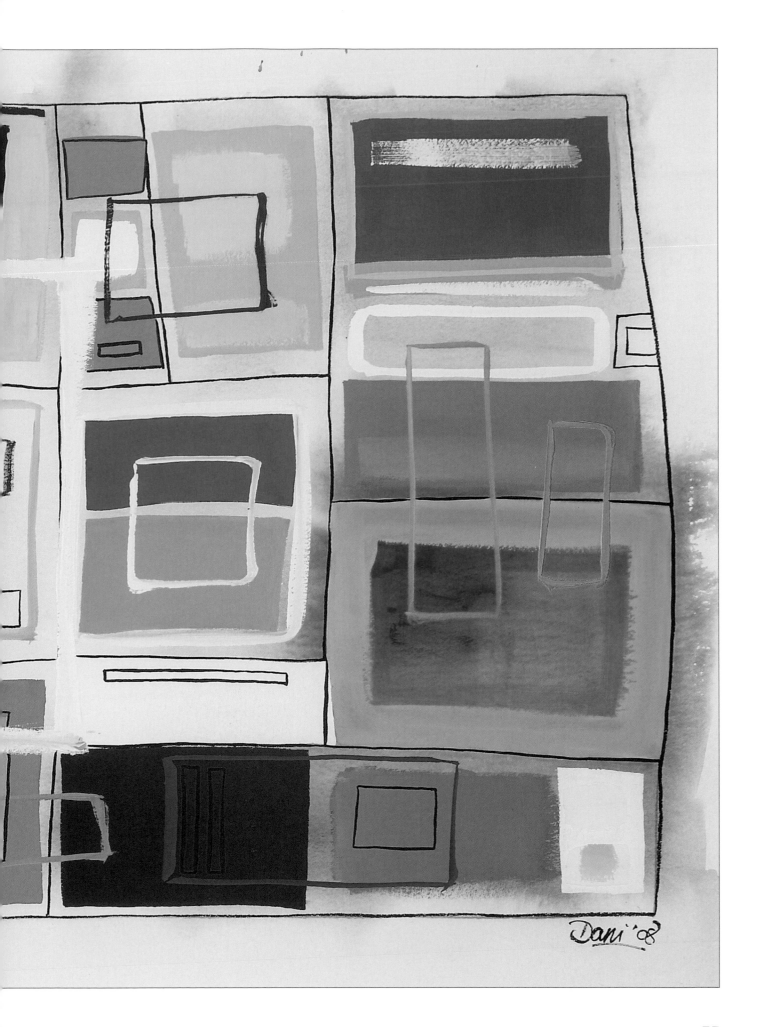

Reflection

Inspired by both light and memory, this piece uses pastels on a water colour paper to ensure a vibrant and bold finish.

It builds up in simple forms from an initial light source, which is gradually surrounded by other elements that come to hold it in place until the whole paper is covered.

It is an excellent opportunity to use your hands with a different medium. Keep a rag nearby to make sure your fingers are clean.

You will need

425gsm (200lb) Not finish water colour paper 65 x 50cm (29½ x 21½in)

Artists' soft pastels (all tint 4): Winsor lemon, Winsor yellow, Winsor red, permanent alizarin crimson, French ultramarine, Winsor blue (red shade), permanent green, Hooker's green, yellow ochre, burnt sienna, ivory black and titanium white

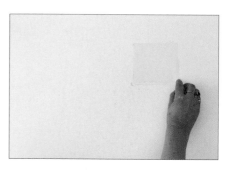

1 Make an initial statement by creating a block of Winsor yellow slightly off-centre. This will be the light source.

2 Edge the top and right with Winsor red, and give the suggestion of the other two sides of the square by adding corners at the end of the lines.

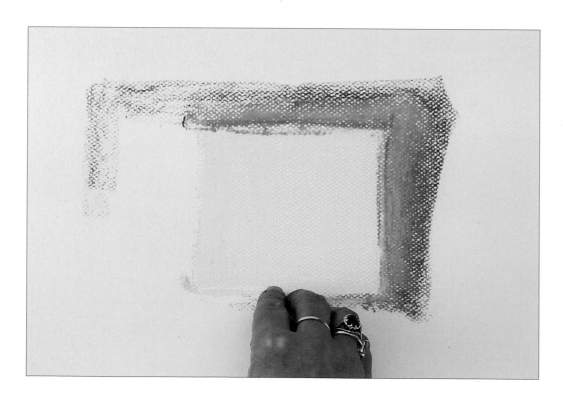

3 Run Winsor yellow inside the red stripes.

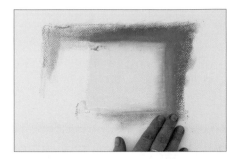

4 Use a clean finger to soften the colours into one another.

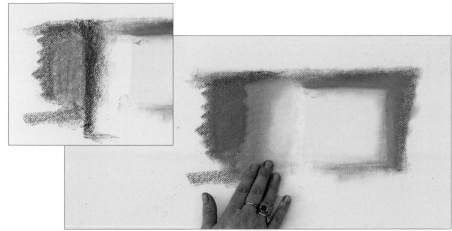

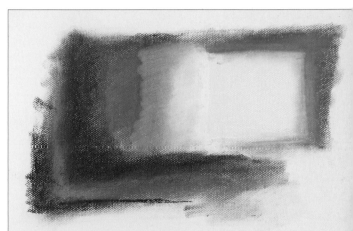

5 Develop the unfinished sides by extending them using Winsor red, alizarin crimson and a little titanium white (see inset), then blend them together. Add more titanium white near the light source and blend again.

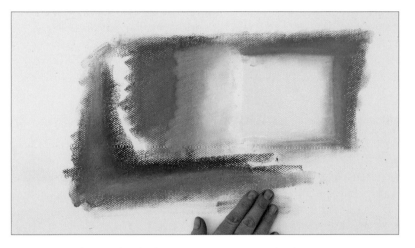

6 Create a field of a darker tone using French ultramarine to create contrast. Prevent it from overwhelming the piece by blending titanium white into the centre, muting the hue.

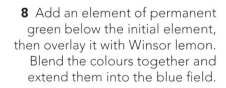

7 Fill the space between the elements with alizarin crimson, and blend it in.

8 Add an element of permanent green below the initial element, then overlay it with Winsor lemon. Blend the colours together and extend them into the blue field.

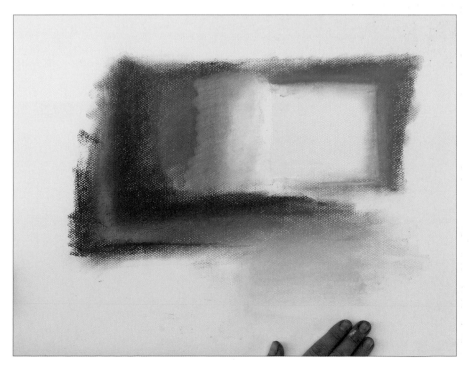

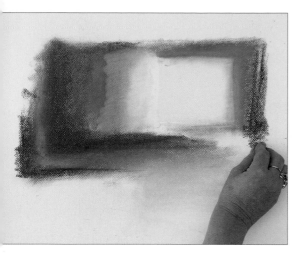 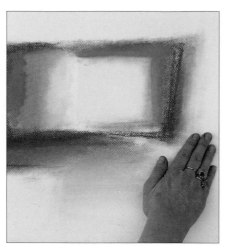 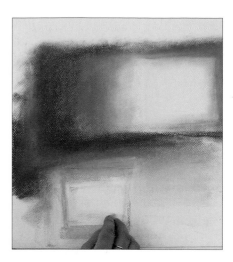

9 Add an alizarin crimson line to the right of the light source, and a Winsor red line to the right of that.

10 Create an orange area by adding Winsor yellow to the right of the red lines and blending the colours together. Lift the tone by adding and blending white to the extreme right.

11 Create a new element to balance the light source from Winsor blue (red shade) layered on yellow ochre. Add a stroke of Permanent green inside to anchor the white of the paper and incorporate it into the picture.

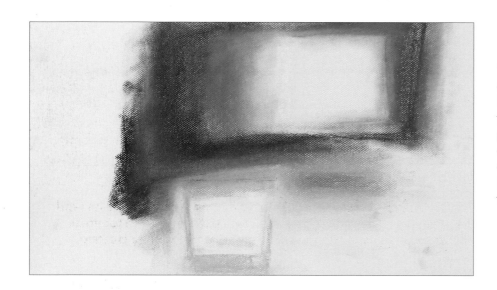

12 Blend the colours of the new element together, then add a Hooker's green stroke beneath the light source to balance the permanent green stroke. Blend the edges of the Hooker's green stroke only, to soften it into the overall image and give it the impression that it is receding into the distance.

13 Surround and frame the piece with a dense field of French ultramarine. Add tonal interest with cerulean blue on the left. Blend the field together, but do not extend it into the rest of the picture. Keep the edge soft, adding titanium white to suggest light near the other elements.

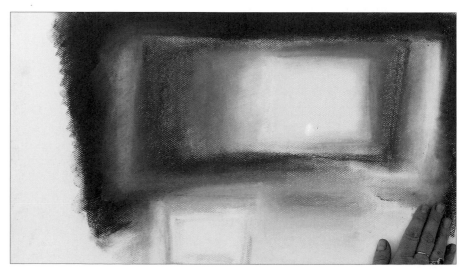

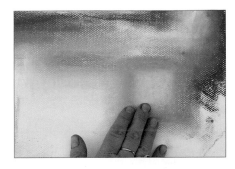

14 Add a cerulean blue element in the lower right, and add titanium white in the centre. Frame it with permanent green and blend the colours together with circular movements.

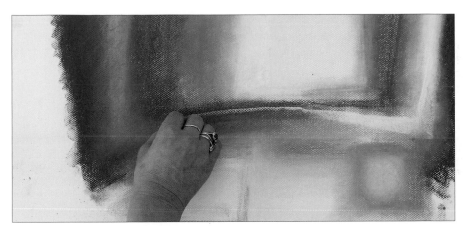

15 Outline the area near the light source on the right and bottom with titanium white.

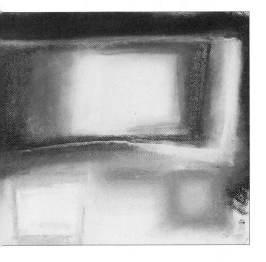

16 Outline the light source at the top by adding a line of Winsor orange and yellow ochre. Blend the colours together carefully.

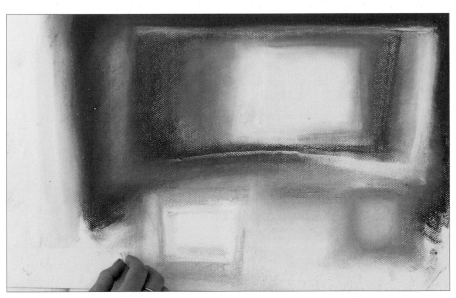

17 Add stripes of permanent green, Winsor lemon, Winsor yellow and then titanium white to the left of the blue field. Blend them together. This area harmonises with the colours used at the bottom, creating colour balance.

18 Link the left-hand, bottom-most and blue fields with a Hooker's green section. Blend it in to the adjacent areas.

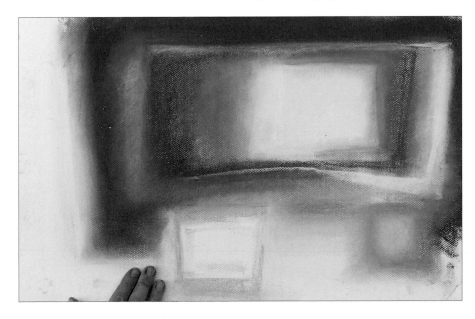

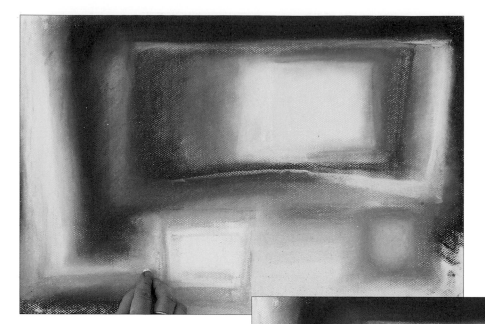

19 Anchor the lower left with a strong section of French ultramarine. Vary the hue by blending in titanium white, but keep the edges fairly obvious. Reinstate the edges with yellow ochre if necessary.

20 Draw a faint streak of yellow ochre across the whole bottom part of the picture, linking the various elements. Add touches of Winsor red here and there to balance the colour in the cooler areas.

21 Draw a streak of Winsor yellow across the whole top, leaving it unblended to act as a 'glaze' sitting on top of the blue.

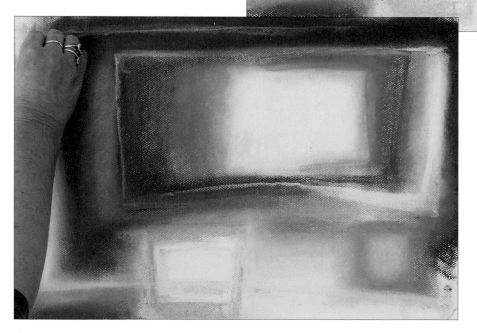

22 Add two strokes of Winsor yellow overlaid with Winsor red in the lower right, and blend the colours together into orange.

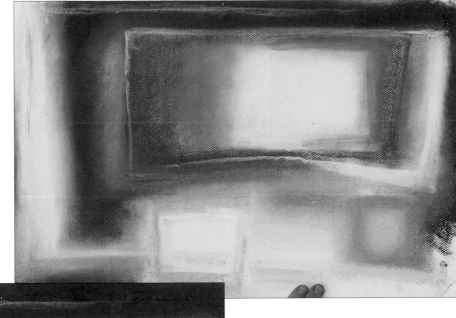

23 Overlay French ultramarine with alizarin crimson around the edges of the paper, then blend the colours together.

24 Smudge in some cerulean blue in the lower central element, and reinforce the light source with Winsor lemon. Add some final touches of the various pastels to emphasise the existing elements.

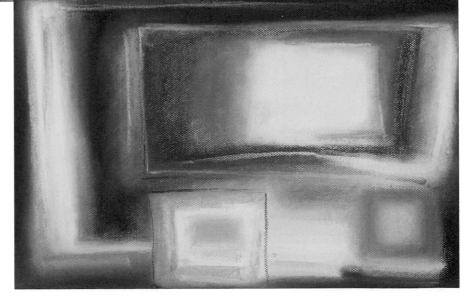

Overleaf:

The completed project.

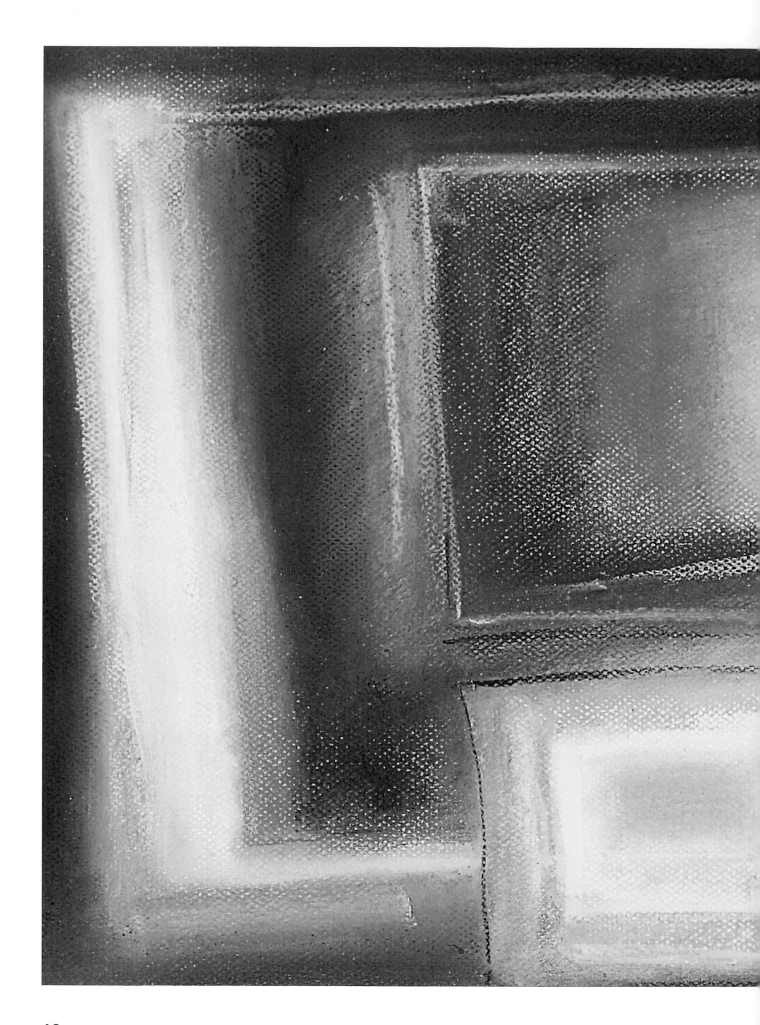

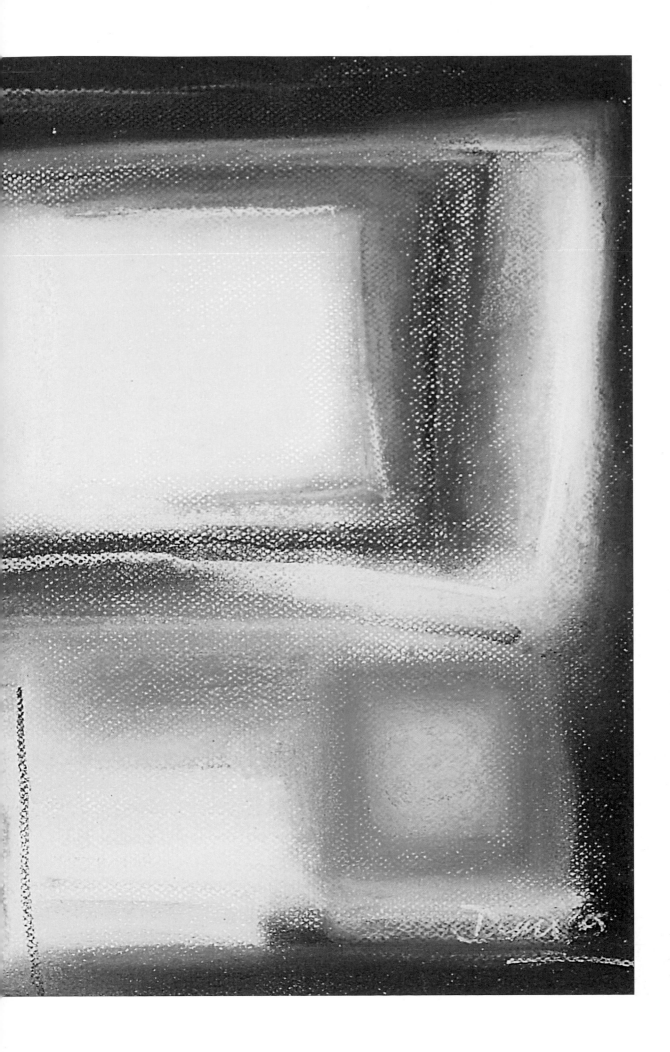

Index

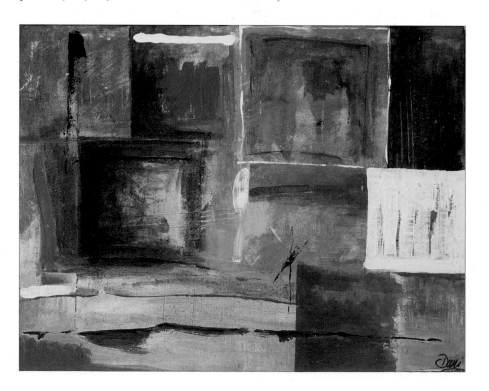

Sunset of a Very Important Person
50 x 40cm (20 x 16in)
This was a painting to celebrate the life of a dear family friend, using some sunset colours. Note the orange square representing the sun itself, sinking below the horizon.